Yellowstone Is...

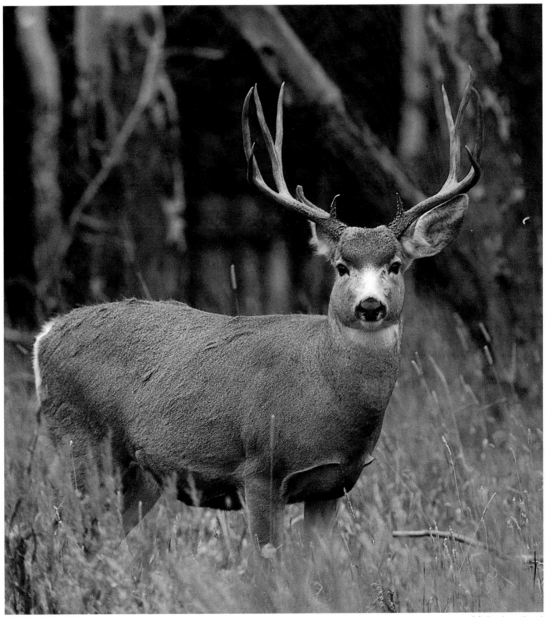

Mule deer buck

Yellowstone Park in verse and photography by Mike Logan

ISBN: 0-937959-20-0

Publishing consultant and production by
Falcon Press Publishing Co., Inc., Helena, Montana

Printed in Hong Kong

FRONT COVER PHOTOS:
Phantom Lake aspen
Aspen grove
Trumpeter swan
Lower Yellowstone Falls
Grizzly bear

BACK COVER PHOTOS:
Gardiner entry point
Golden-mantled ground squirrel
Fountain Paint Pot
Elk calves

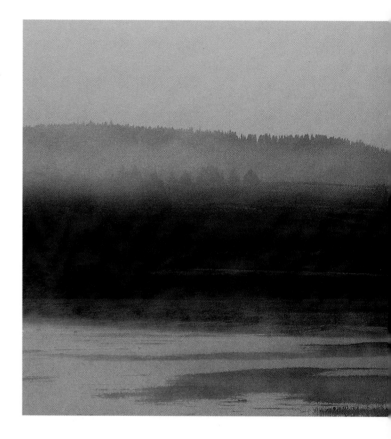

Dedication

This book is dedicated to Mother and Dad who taught me to see beauty everywhere and to be thankful for it.

Mike Logan

Buglin' Bull Press
32 S. Howie, Helena, MT 59601

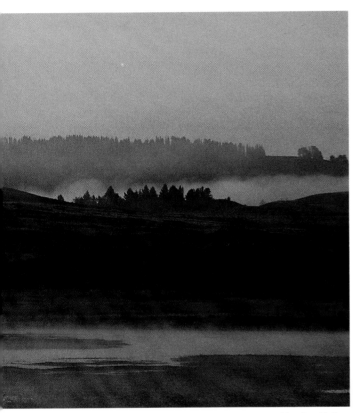

Hayden Valley

Introduction

I almost stumbled over the old gentleman.

He was kneeling to fill his water jug at the sweet-watered spring that surfaces near Soda Butte in the Northeastern part of Yellowstone.

"Young feller," he said, "if I had a job where I had to carry that much gear and work that hard, I think I'd quit!"

"I probably would too," I replied, "but this is for fun!"

Loaded down with all my gear, I must have looked more like a pack mule than a photographer. I had just spent the morning photographing the bull bison that frequent the area around the ancient inactive cone of Soda Butte.

"For seventy three years I've been in and around the park," he volunteered as we climbed the road bank, "and every day I see something different."

It was easy to sense the love that I have heard echoed in the voices of so many others; seasoned park watchers, first time visitors, part time employees and park rangers alike.

I hope, through this book, to lead the first time visitor to see things he or she might not otherwise have seen. I do not plan to stray far from the road. There is plenty to see nearby.

I'd also like to carry long time visitors back to well remembered spots to visit well remembered friends. I only wish that these readers could share their memories with me.

Finally, I would like this book to introduce my Yellowstone to those who may never have the chance to see it for themselves, but who may, nevertheless, feel its far off siren song.

My hope, then, is to convey, through words and pictures, what "Yellowstone Is . . ." to me and to many others who love this great sprawling park so much.

In my photographic search for what "Yellowstone Is . . .", I have spent nearly twenty years and as the old man said, "Every day I see something different." I hope I always do!!

Mike Logan
January 1987

Yellowstone Is . . .

A stormin' bull
A warm blue stream
And sundown through a geyser's steam.
It's shining peaks
And thunderin' falls
And trumpeters' melodious calls.

It's bubblin' pots
And one horned rams
And beavers workin' near their dams.
It's Mammoth Springs
A coyote's stare
And blossoms on a prickly pear.

It's ox-bowed creeks
And stagecoach rides
And logjams where the otter hides.
It's sandhill cranes
A geyser's plume
And hillsides where the wildflowers bloom.

It's whistlin' wings
Old bulls alone
A canyon on the Yellowstone.
It's knockin' heads
And tiny teal
A weasel huntin' for a meal.

It's junipers
And valleys high
Old Faithful reachin' to the sky.
It's brown-eyed ewes
A dragon's mouth
And wild geese wingin' from the south.

It's cutthroat trout
And momma moose
And icebound falls just breakin' loose.
It's pronghorns swift
High country gold
Wind twisted trees all gnarled and old.

It's monkeyflowers
A fawn new born
And swans that swim the misty morn.
It's trees long dead
And grizzly sows
And harem masters movin' cows.

It's snowshoe hares
And battles done
A mountain roarin' in the sun.
It's streams to cross
A snowblind owl
And nestin' grounds for waterfowl.

It's emperors
Storms from the west
A mountain bluebird at the nest.
It's solitude
Trees turned to stone
And layers on an ancient cone.

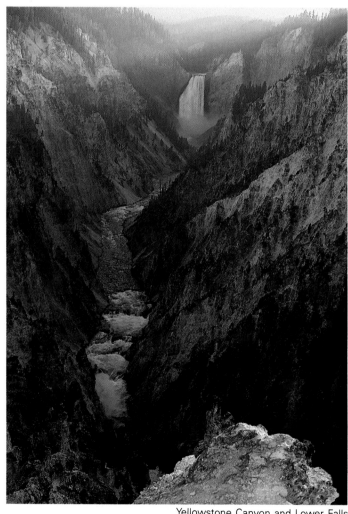

Yellowstone Canyon and Lower Falls

It's saucy jays
John Colter's Hell
A rock shaped like the Liberty Bell.
It's referees
A visitor rare
And battle songs that fill the air.

It's golden dawns
And paintbrush bright
A bull moose spoilin' for a fight.
It's chipmunks quick
And silvered trees
Fog risin' when the rivers freeze.

It's yellow-heads
And new green reeds
A riffle where the brown trout feeds.
It's bison calves
The winter god
And mountain monarchs on the prod.

It's fireweed
Sun-gilded shrouds
And snow trails leadin' to the clouds.
It's waters warm
A jack turned white
And full moons when day turns to night.

It's muley fawns
A gray-brown hen
A marmot watchin' near his den.
It's velvet crowns
A dipper's log
And far off bugles in the fog.

It's bright-eyed lambs
And steam-shaped forms
And bull elk waitin' out the storms.
It's bridal veils
A pika's hay
And magpies up to greet the day.

It's tiny friends
A day new dawned
And aspens mirrored in a pond.
It's bottoms up
And bedded bucks
And snowblowers set on high-wheeled trucks.

It's prairie babes
And hawks that soar
A raven croakin' ''Nevermore.''
It's Tower Falls
And golden gates
And blue grouse dancin' for their mates.

It's ermine white
A hatch of flies
And mountains where great rivers rise.
It's fabled streams
A high skied tune
And ghosts that stalk the hunger moon.

It's fall black bears
A soft sunrise
And baby ospreys' great keen eyes.
It's bison cold
And lodgepole pines
And winter elk in long cold lines.

Yellowstone Is . . .

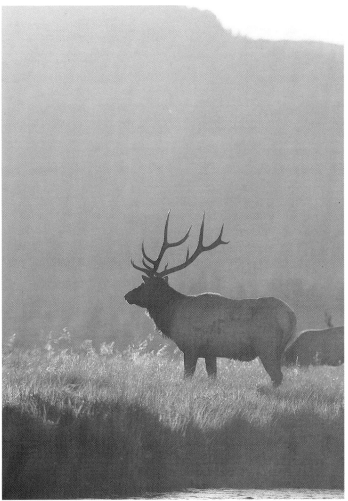
Bull elk

Yellowstone Is . . .

A stormin' bull
A warm blue stream
And sundown through a geyser's steam.
It's shining peaks
And thunderin' falls
And trumpeters' melodious calls.

A stormin' bull

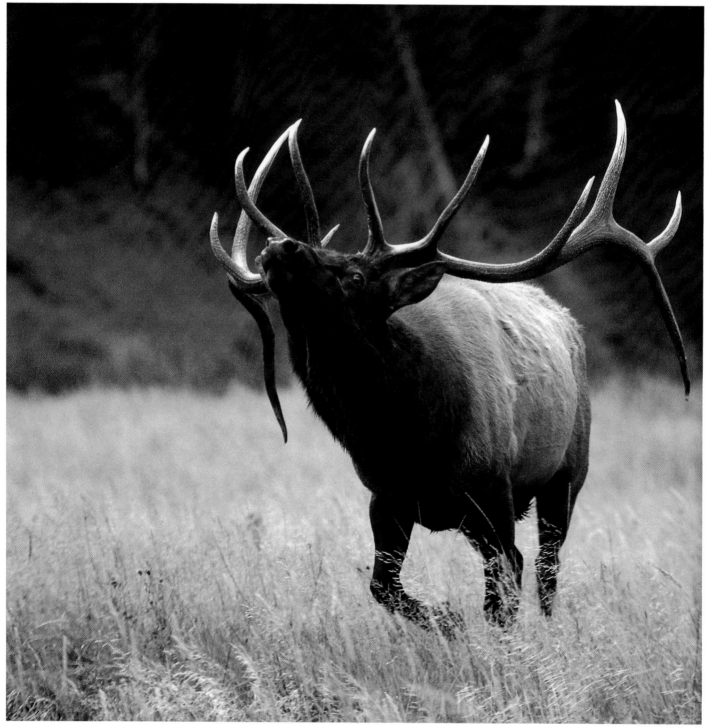

Bull elk

A warm blue stream

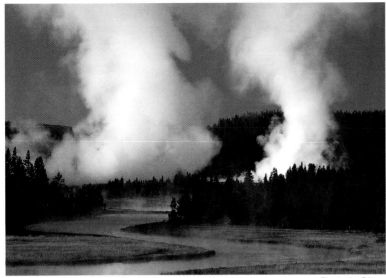

Firehole River

And sundown through a geyser's steam

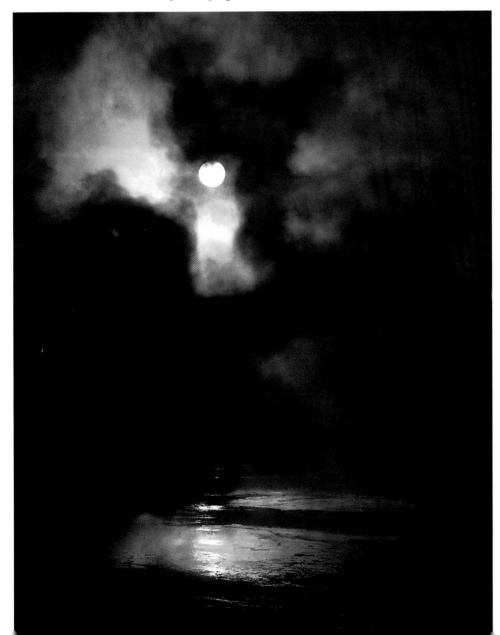

Fountain Paint Pot area

It's shining peaks

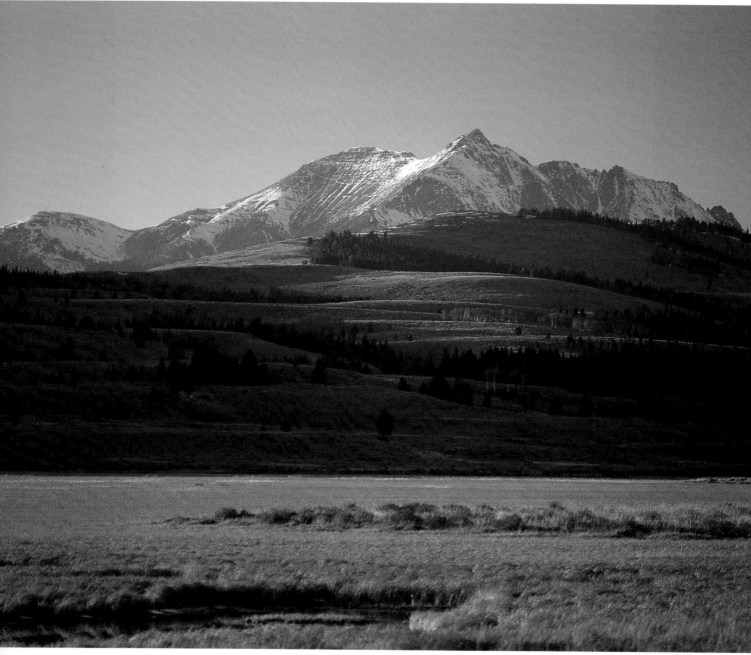

Electric Peak

And thunderin' falls

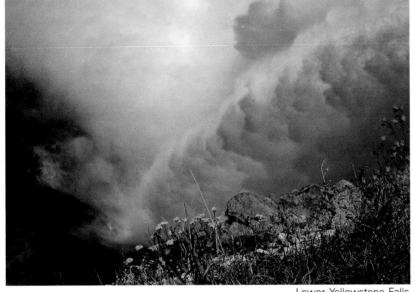

Lower Yellowstone Falls

Lower Yellowstone Falls

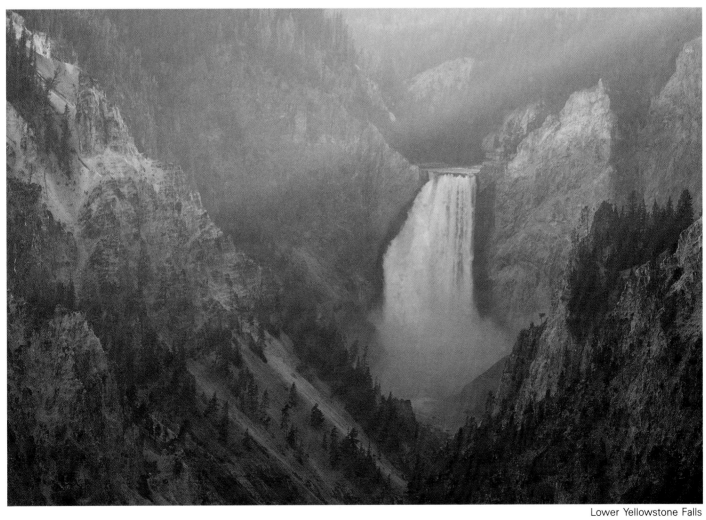

Lower Yellowstone Falls

7

And trumpeters' melodious calls.

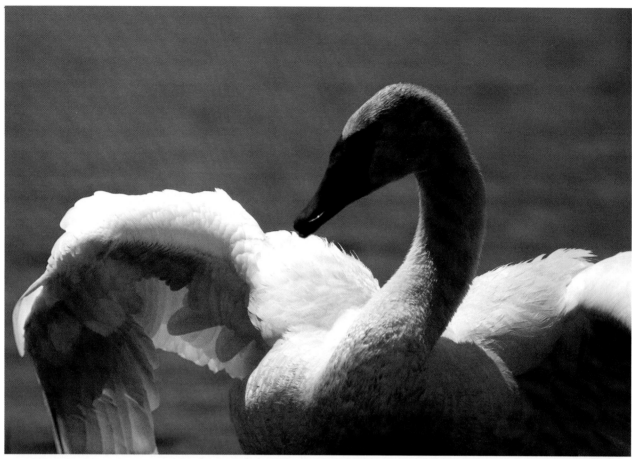

Trumpeter swan

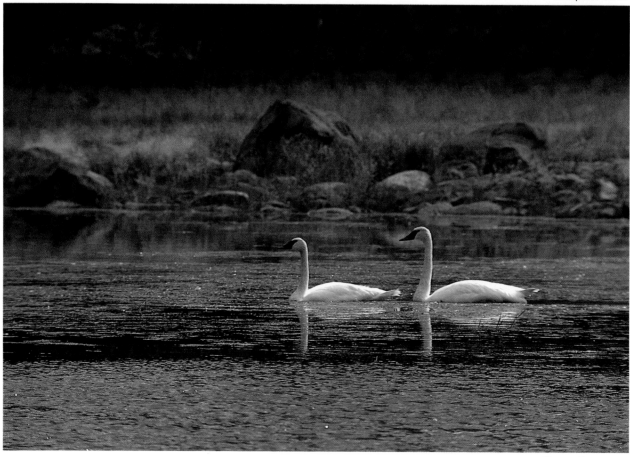

Trumpeter swans

It's bubblin' pots
And one horned rams
And beavers workin' near their dams.
It's Mammoth Springs
A coyote's stare
And blossoms on a prickly pear.

It's bubblin' pots

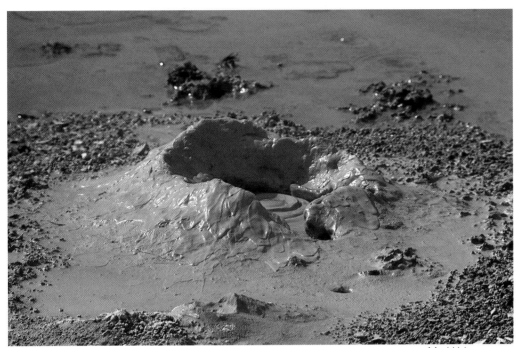

Mud Volcano area

And one horned rams

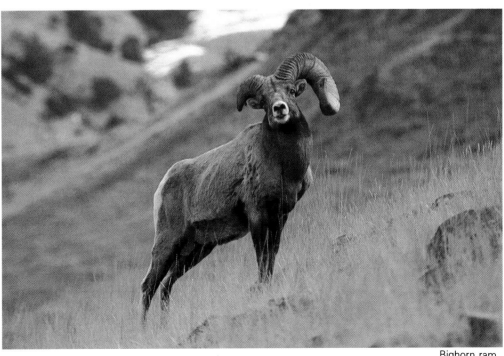

Bighorn ram

And beavers workin' near their dams.

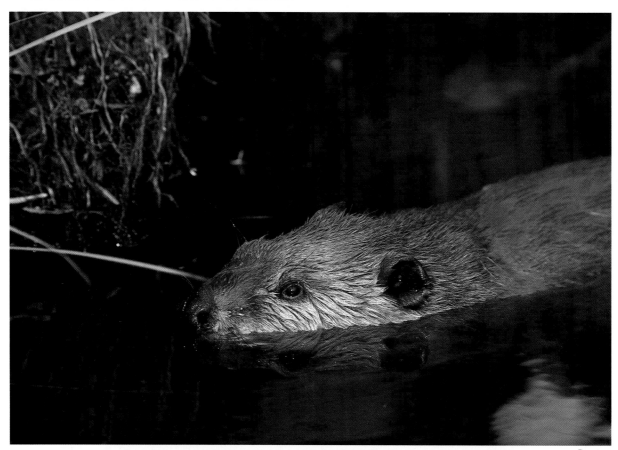

Beaver

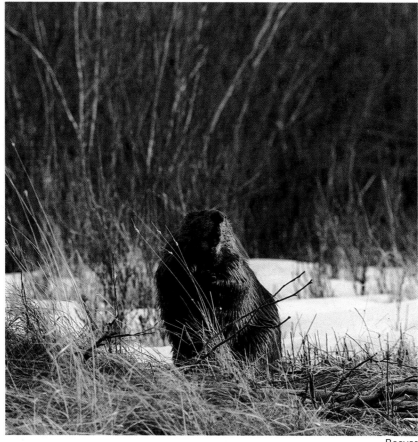

Beaver

It's Mammoth Springs

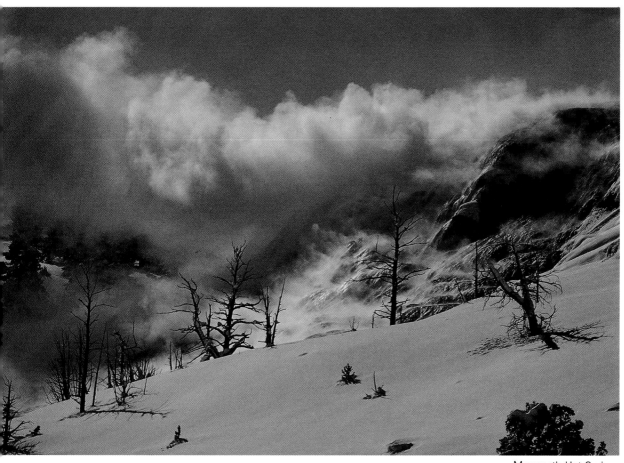

Mammoth Hot Springs

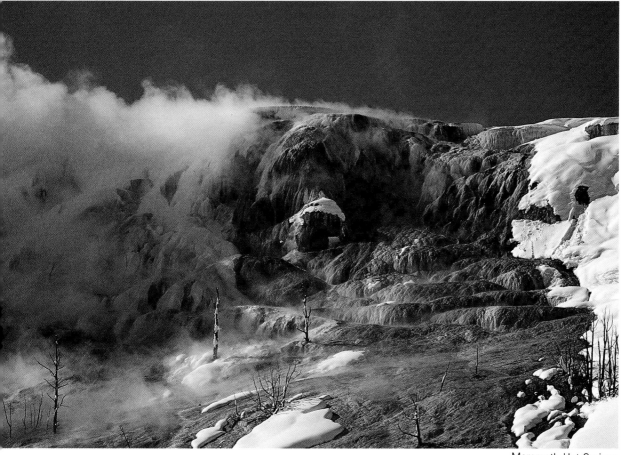

Mammoth Hot Springs

A *coyote's stare*

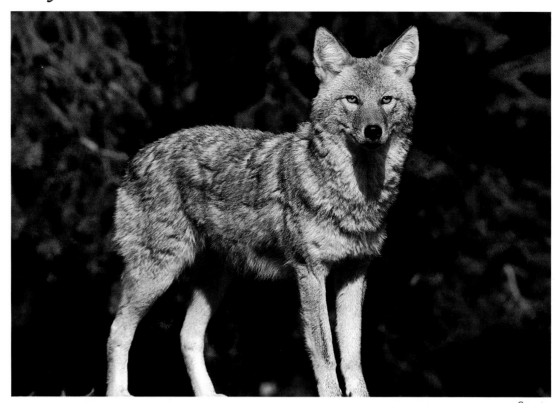

Coyote

And *blossoms on a prickly pear.*

Prickly pear cactus

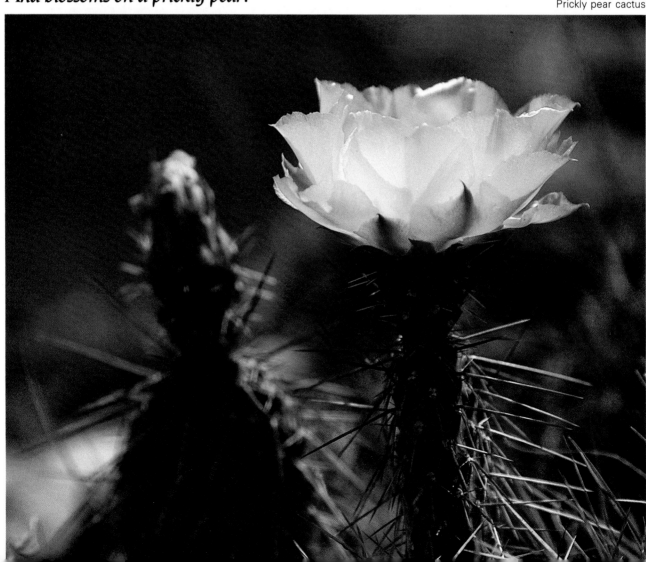

It's ox-bowed creeks
And stagecoach rides
And logjams where the otter hides.
It's sandhill cranes
A geyser's plume
And hillsides where the wildflowers bloom.

It's ox-bowed creeks

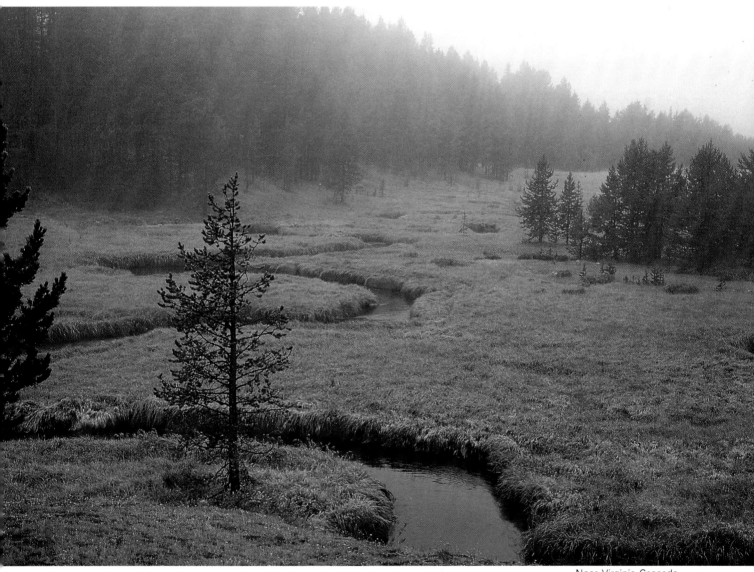

Near Virginia Cascade

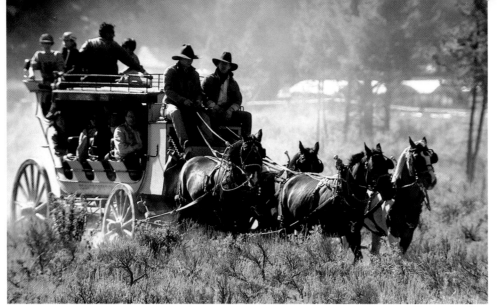

And stagecoach rides

Tower Junction

And logjams where the otter hides.

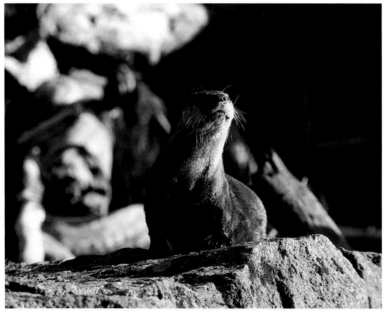

Otter

Otter

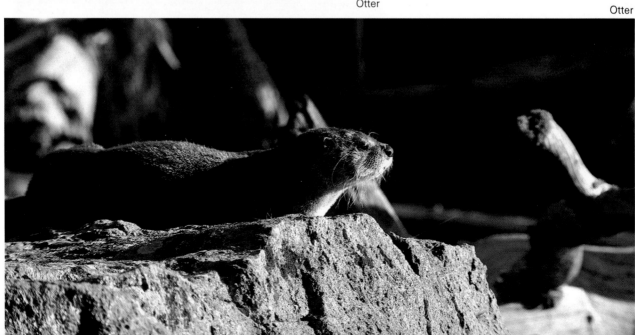

It's sandhill cranes

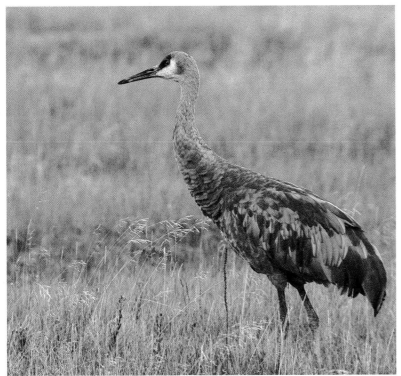

Sandhill crane

A geyser's plume

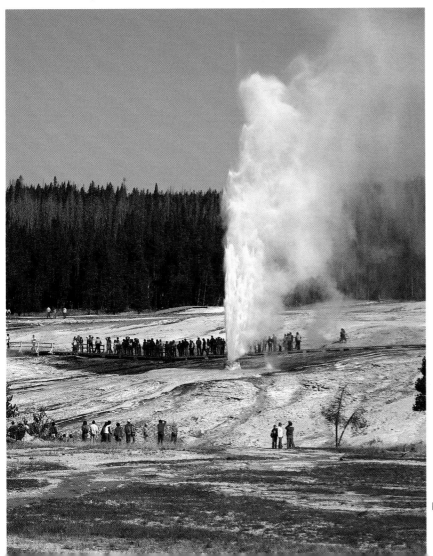

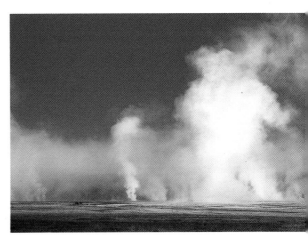

Fountain Paint Pot area

Riverside Geyser

15

And hillsides where the wildflowers bloom.

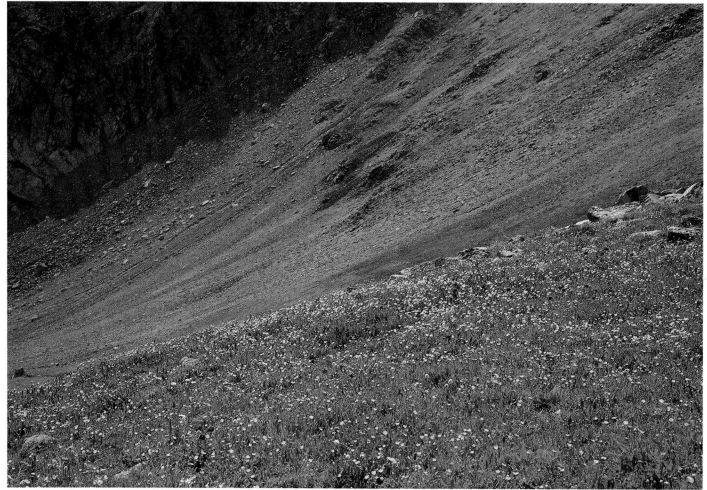

Northeast Entrance area

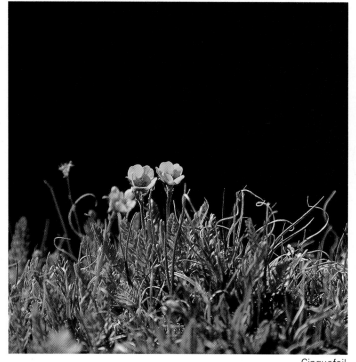

Cinquefoil

Sticky geranium

It's whistlin' wings
Old bulls alone
A canyon on the Yellowstone.
It's knockin' heads
And tiny teal
A weasel huntin' for a meal.

It's whistlin' wings

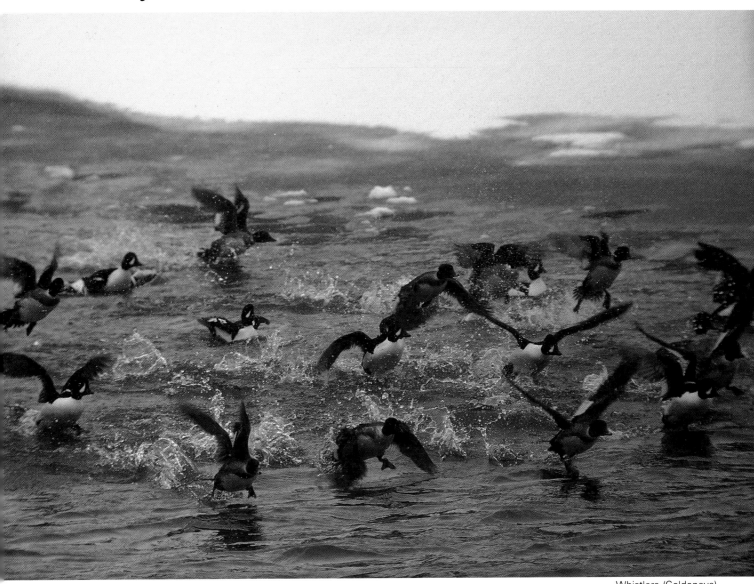

Whistlers (Goldeneye)

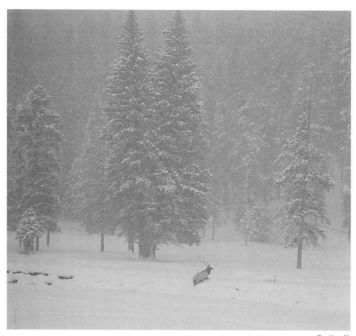

Old bulls alone

Bull elk

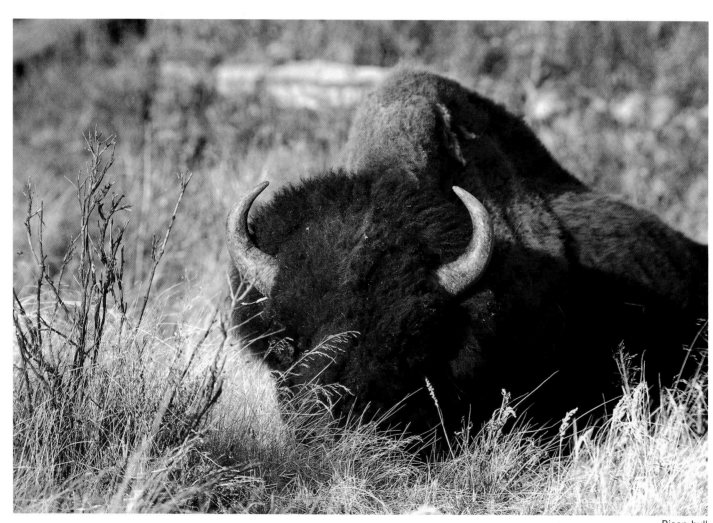

Bison bull

A *canyon on the* Yellowstone.

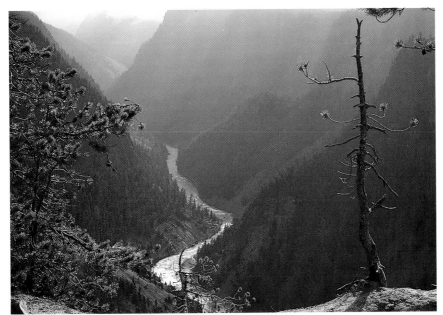

Canyon area

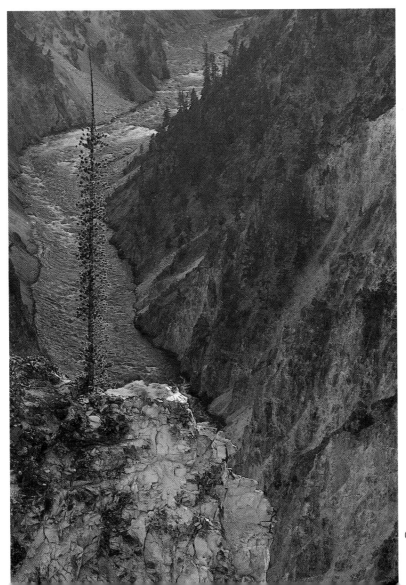

Canyon area

19

It's knockin' heads

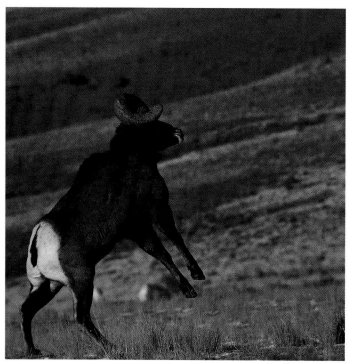

Bighorn ram

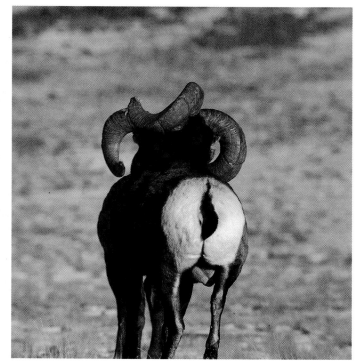

Bighorn rams

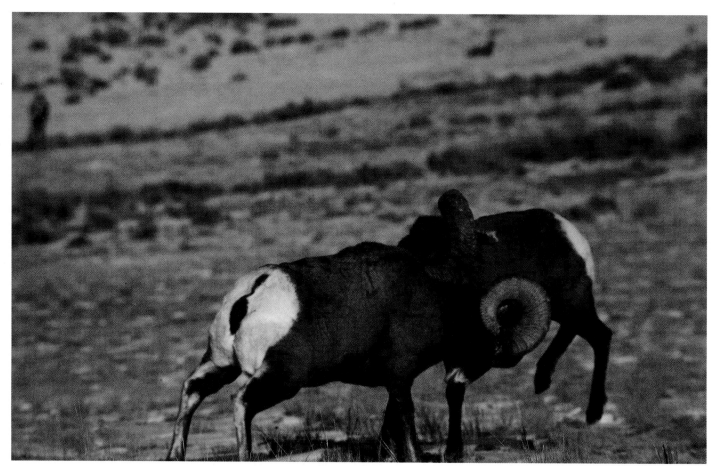

Bighorn rams

And tiny teal

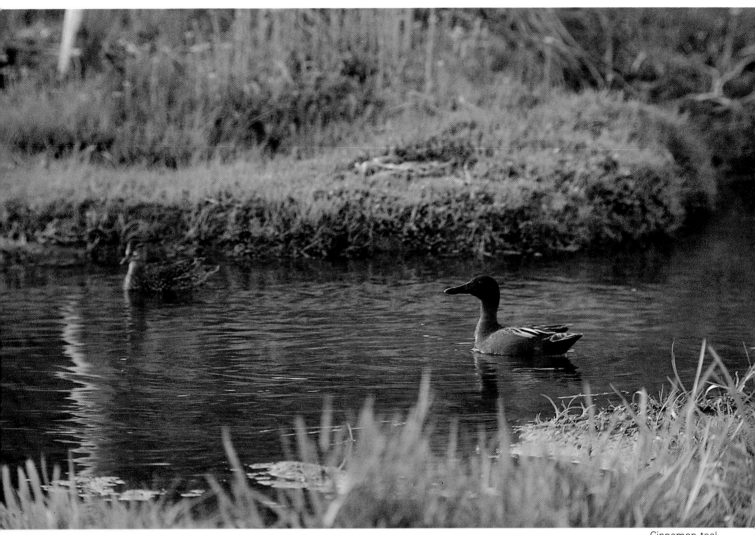

Cinnamon teal

A *weasel huntin'* for a meal.

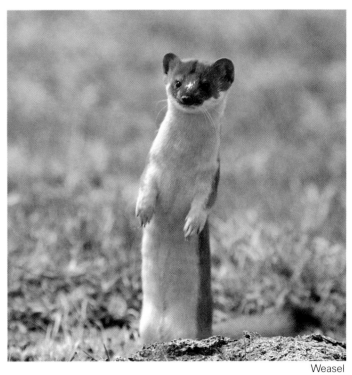

Weasel

It's junipers
And valleys high
Old Faithful reachin' to the sky.
It's brown-eyed ewes
A dragon's mouth
And wild geese wingin' from the south.

It's junipers

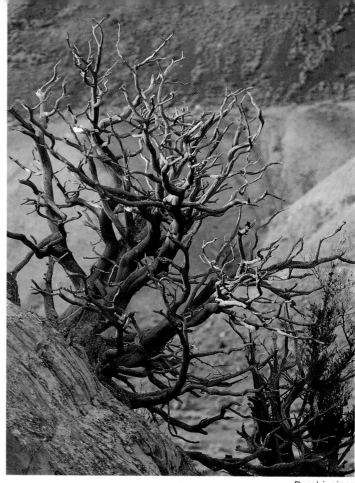

Dead juniper

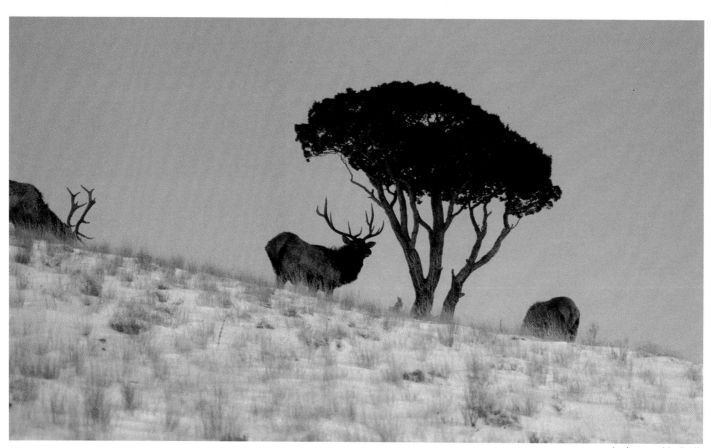

Juniper and bull elk

And valleys high

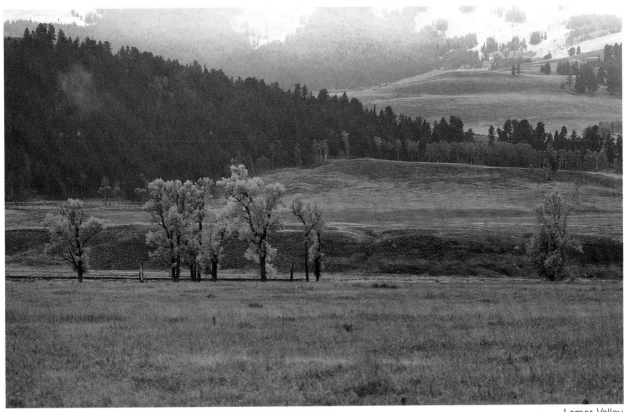

Lamar Valley

Hayden Valley

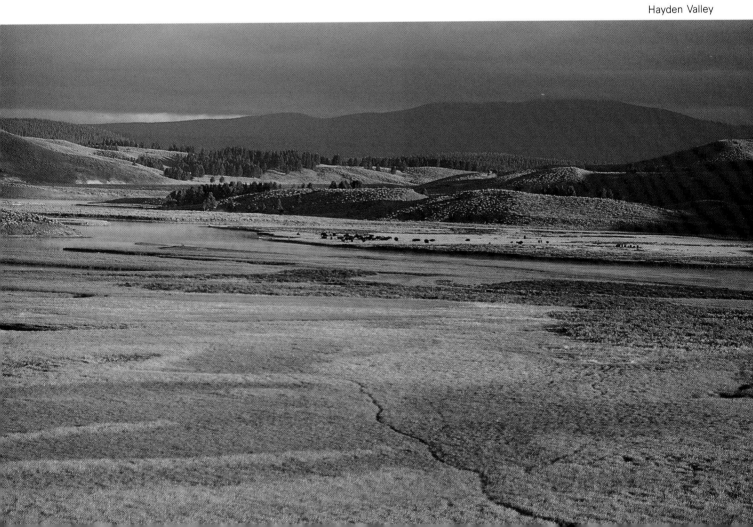

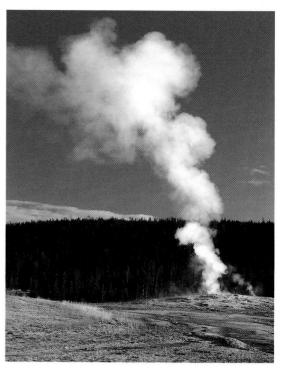

Old Faithful

Old Faithful reachin' to the sky.

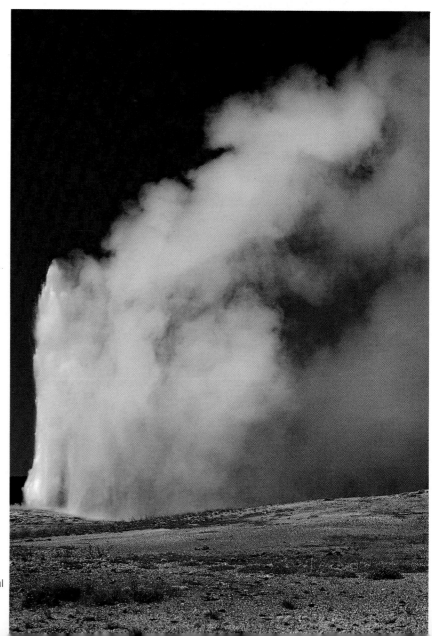

Old Faithful

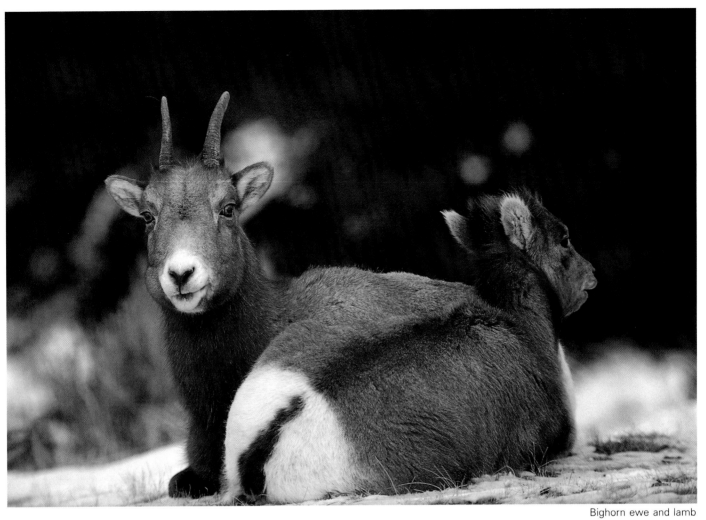

Bighorn ewe and lamb

It's brown-eyed ewes

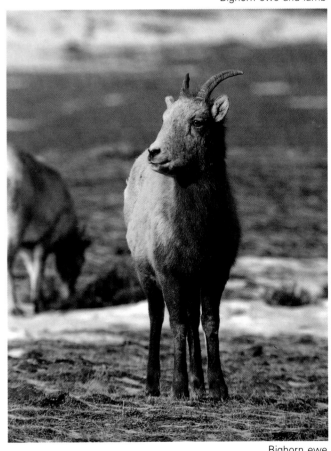

Bighorn ewe

25

A *dragon's mouth*

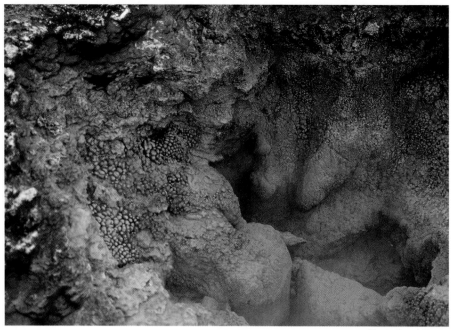

Black Sand Basin

And wild *geese wingin'* from the south.

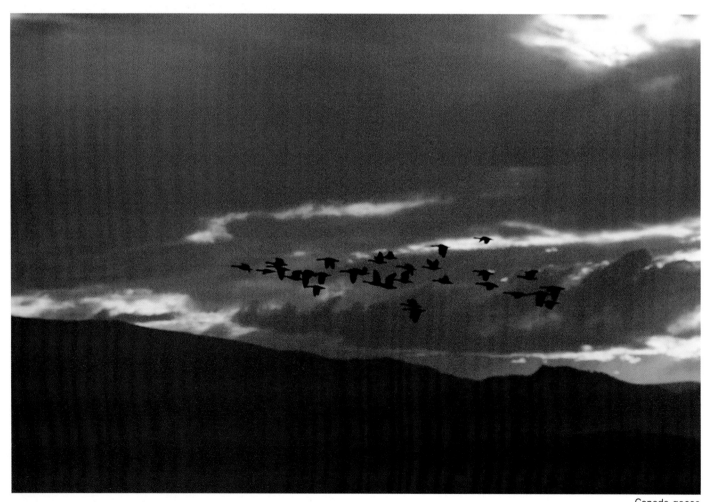

Canada geese

26

It's cutthroat trout
And momma moose
And icebound falls just breakin' loose.
It's pronghorns swift
High country gold
Wind twisted trees all gnarled and old.

It's cutthroat trout

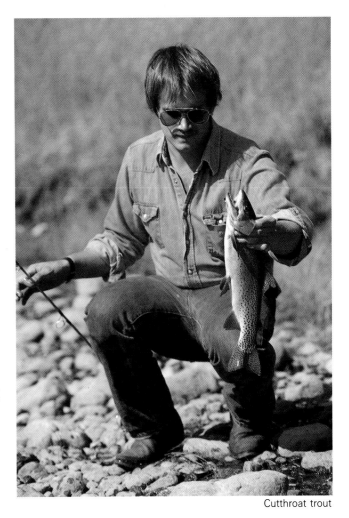

Cutthroat trout

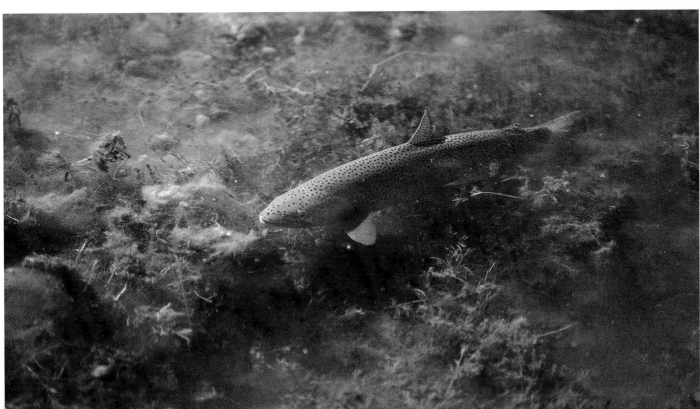

Cutthroat trout

And momma moose

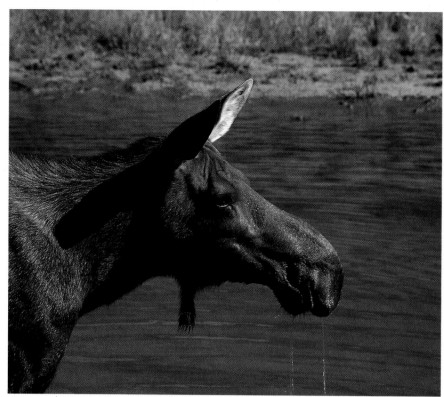

Cow moose

And icebound falls just breakin' loose.

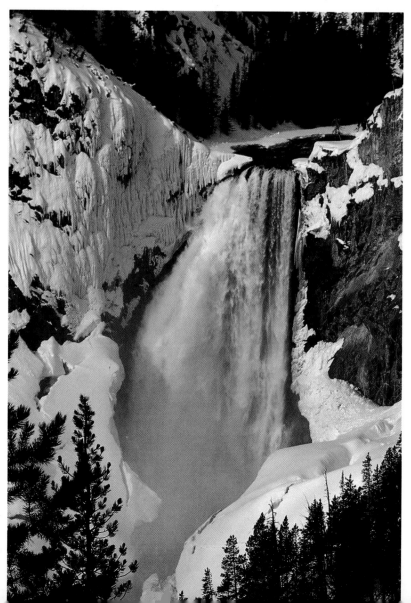

Lower Falls

28

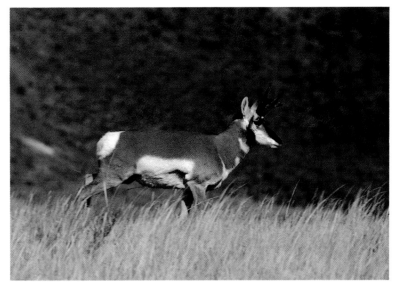

It's pronghorns swift

Pronghorn antelope

Pronghorn antelope

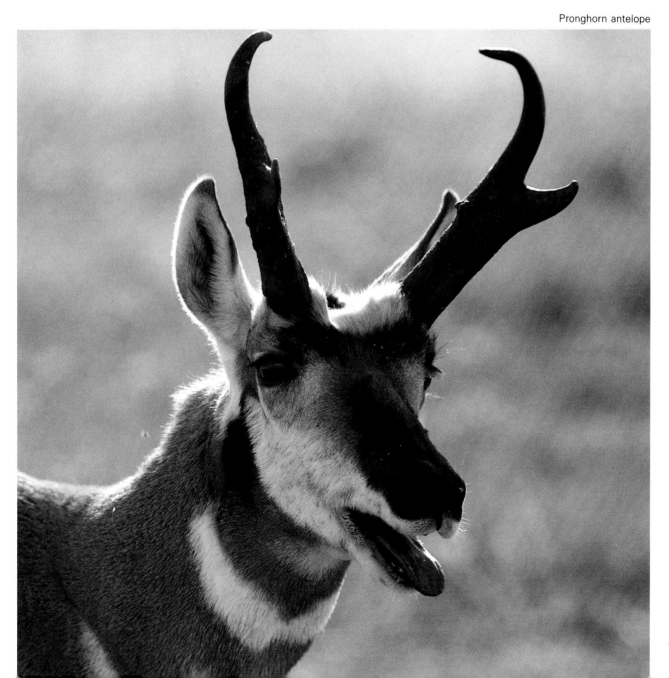

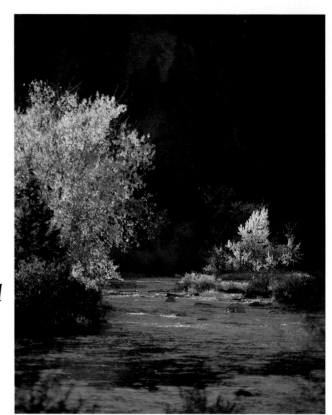

High country gold

Cottonwoods, Gardner River

Aspen

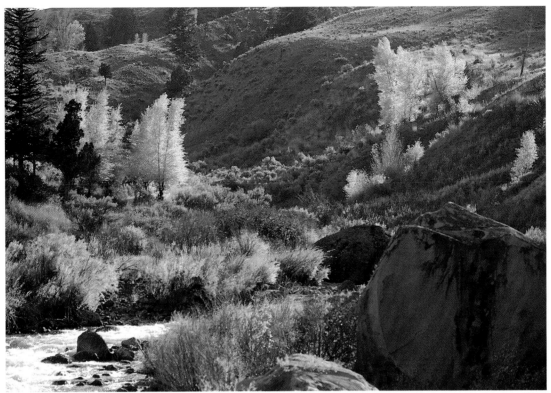

Cottonwoods, Gardner River

Wind twisted trees all gnarled and old.

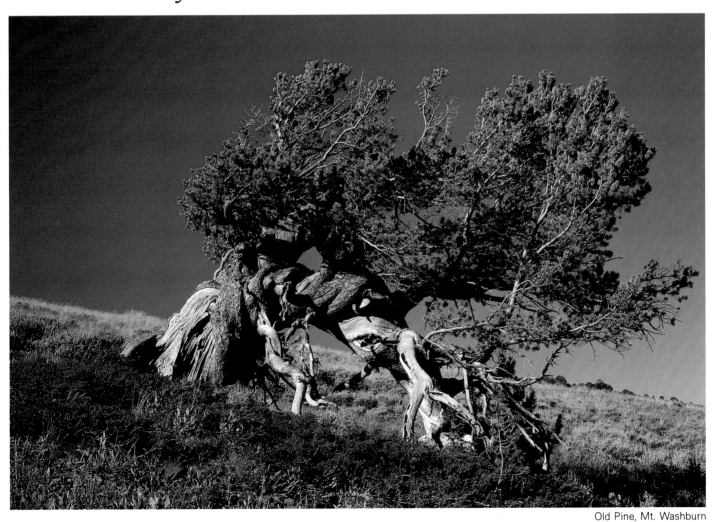

Old Pine, Mt. Washburn

It's monkeyflowers
A fawn new born
And swans that swim the misty morn.
It's trees long dead
And grizzly sows
And harem masters movin' cows.

It's monkeyflowers

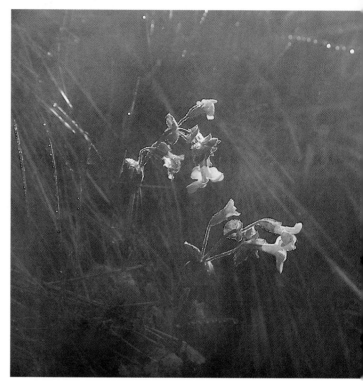

Yellow monkeyflower

A fawn new born

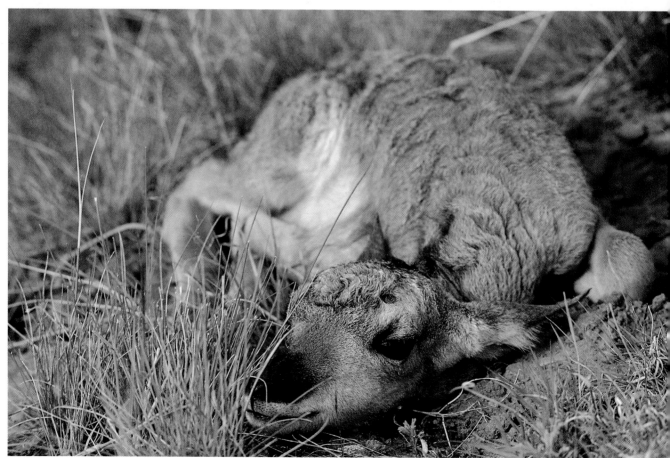

Pronghorn fawn

And swans that swim the misty morn.

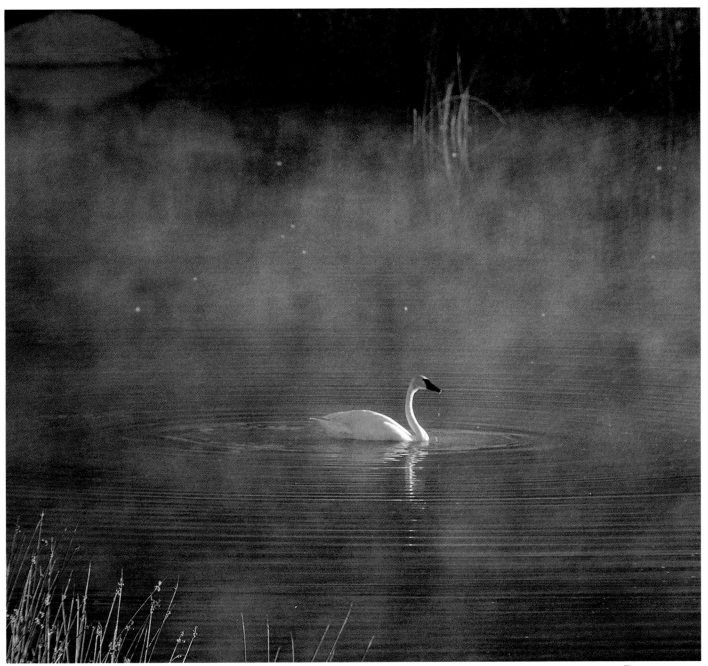

Trumpeter swan

It's trees long dead

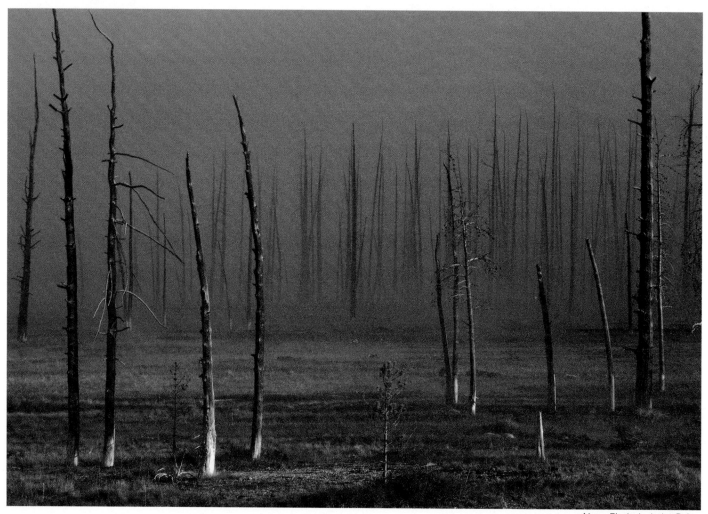

Near Firehole Lake Drive

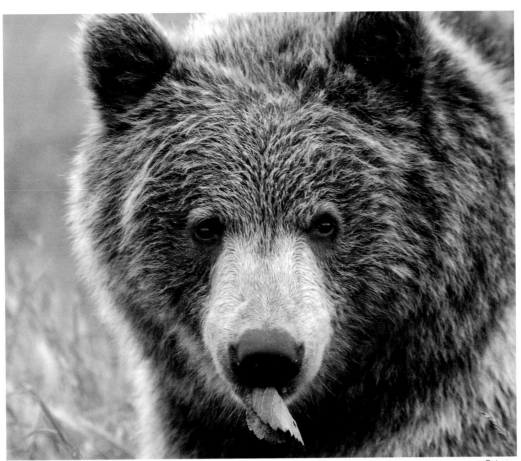
Grizzly

And grizzly sows

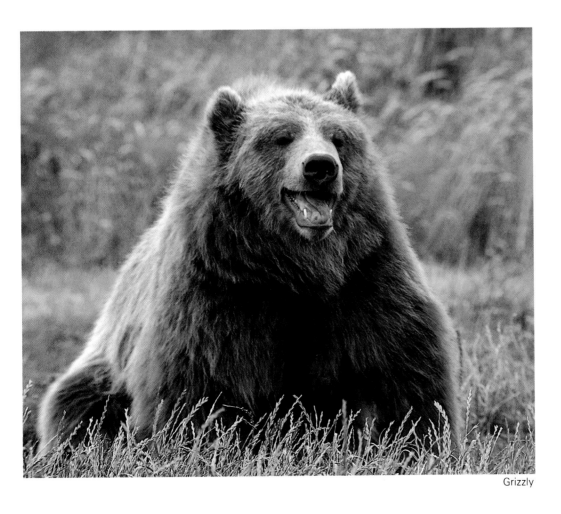
Grizzly

And harem masters movin' cows.

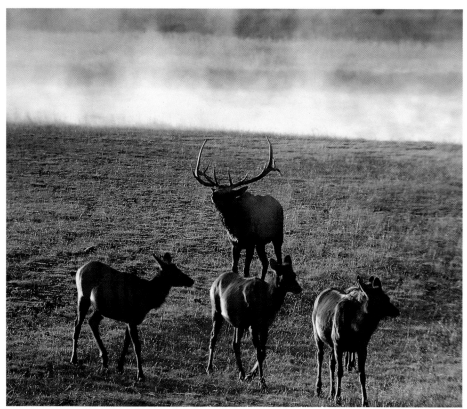

Bull elk and cows

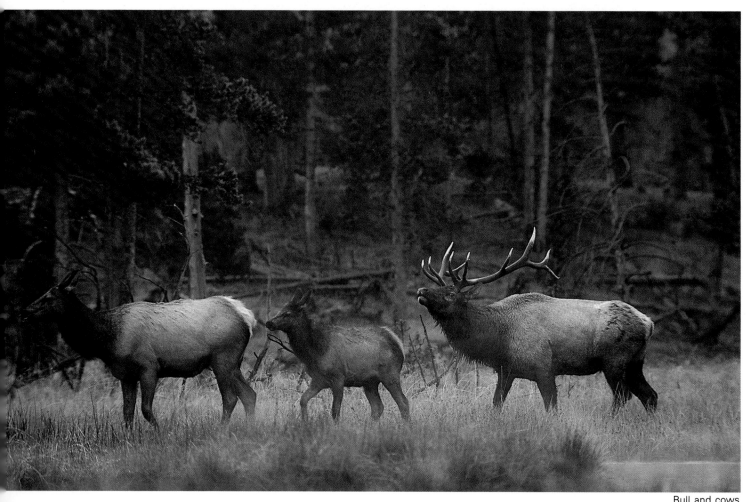

Bull and cows

It's snowshoe hares
And battles done
A mountain roarin' in the sun.
It's streams to cross
A snowblind owl
And nestin' grounds for waterfowl.

It's snowshoe hares

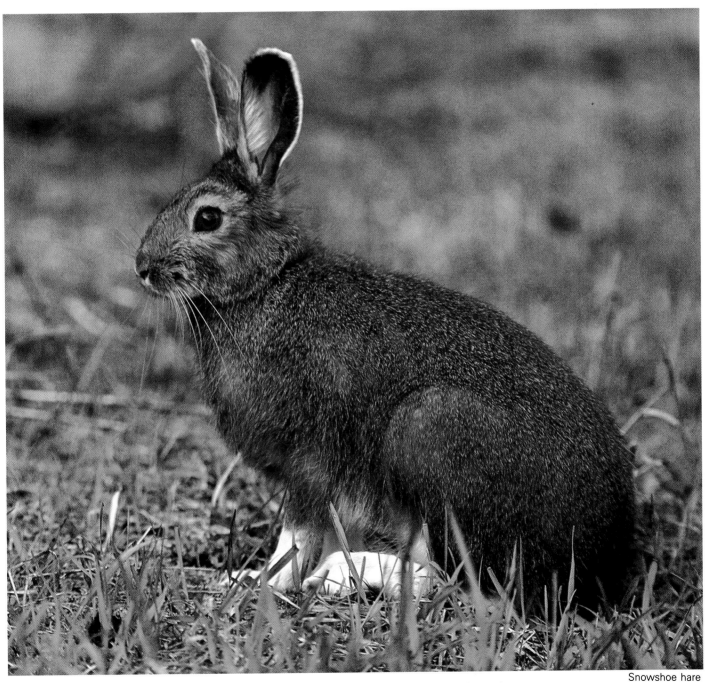

Snowshoe hare

And battles done

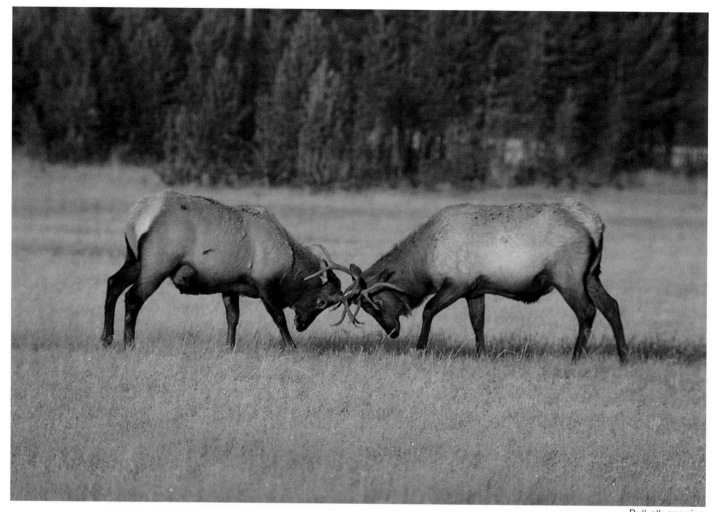

Bull elk sparring

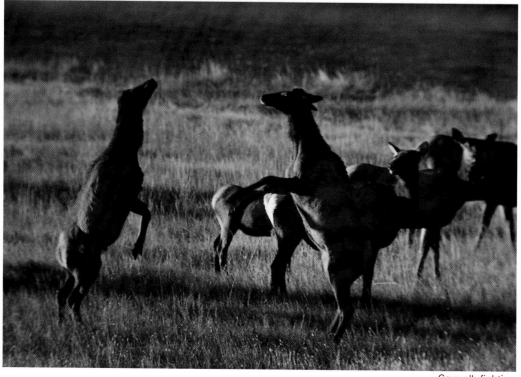

Cow elk fighting

A mountain roarin' in the sun.

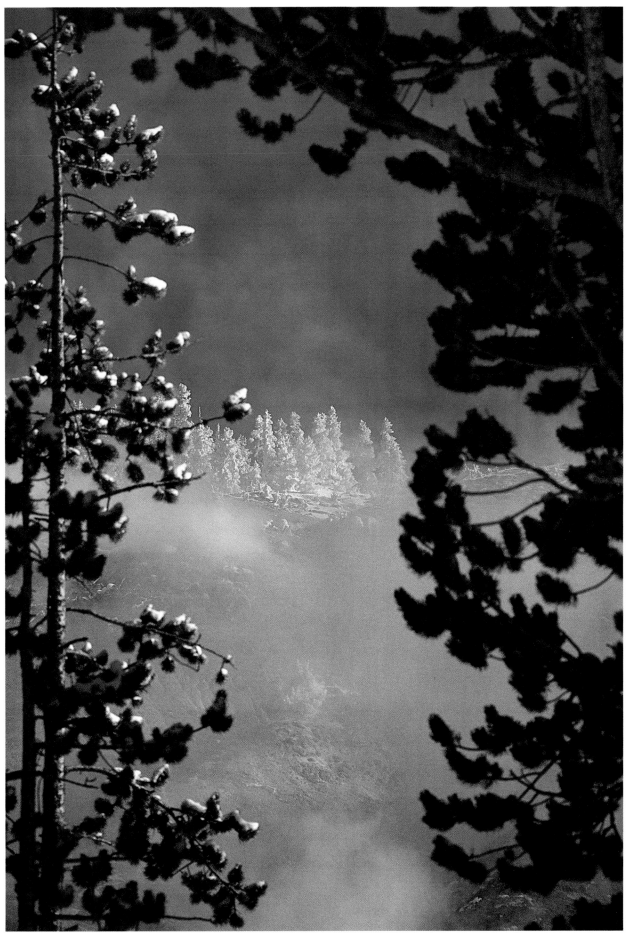

Roaring Mountain

It's streams to cross

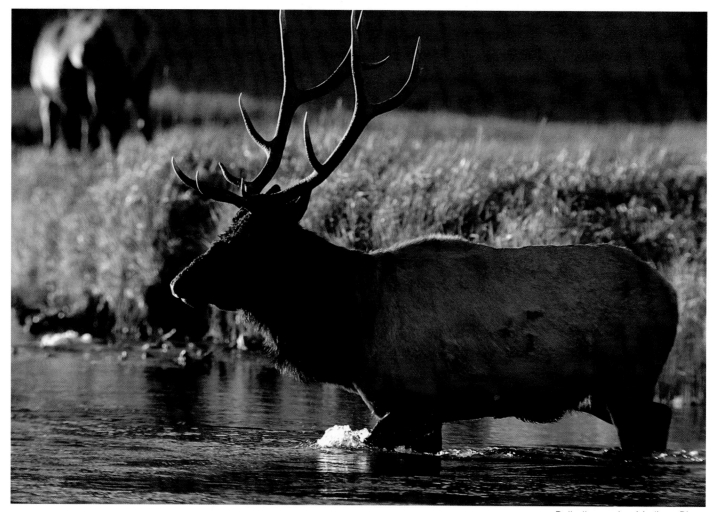

Bull elk crossing Madison River

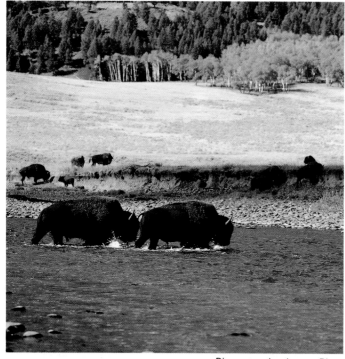

Bison crossing Lamar River

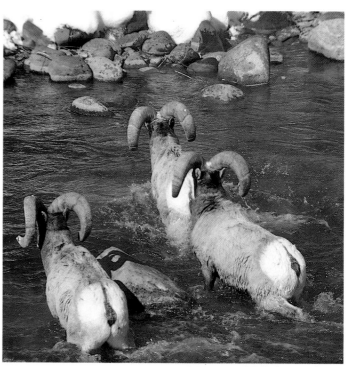

Bighorn rams crossing Gardner River

A *snowblind owl*

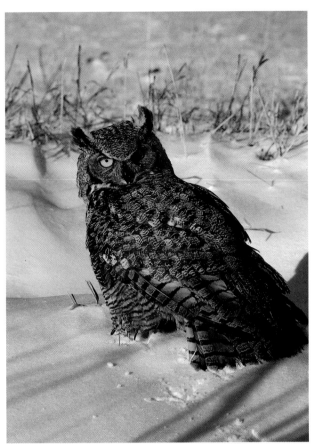

Great horned owl

And *nestin' grounds for waterfowl.*

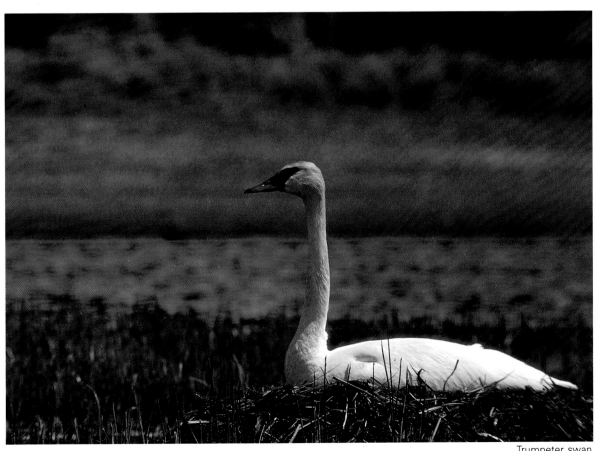

Trumpeter swan

It's emperors
Storms from the west
A mountain bluebird at the nest.
It's solitude
Trees turned to stone
And layers on an ancient cone.

It's emperors

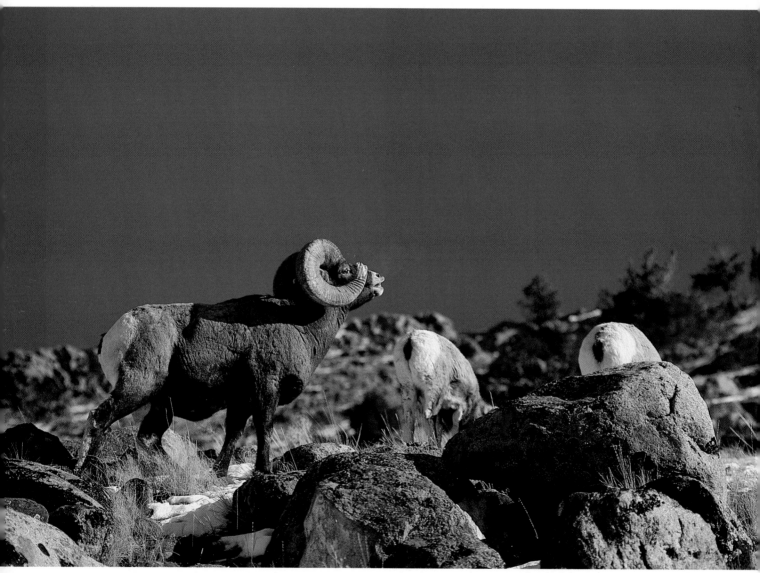

Bighorn ram

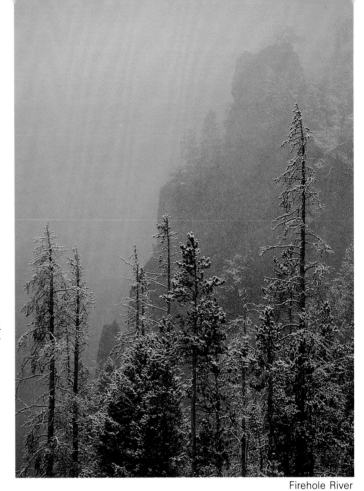

Storms from the west

Firehole River

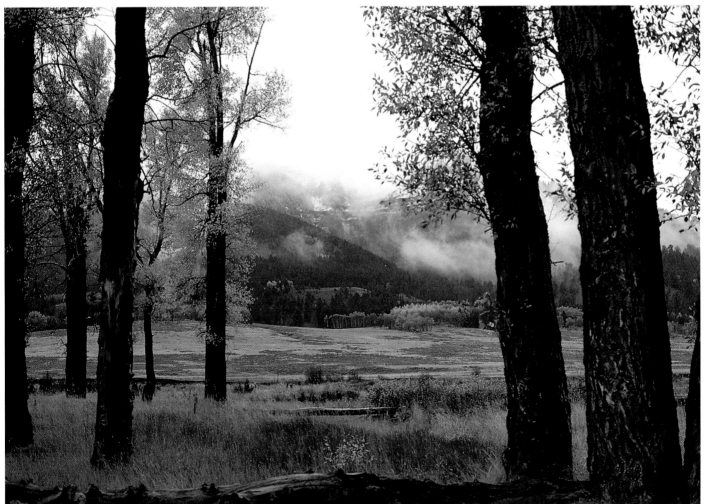

Lamar Valley

43

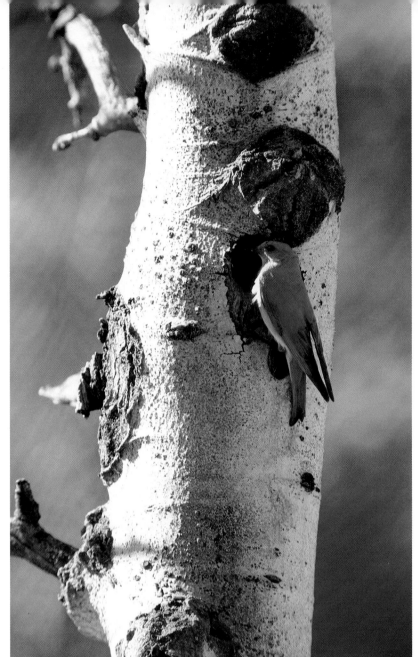

Mountain bluebird

A *mountain bluebird at the nest.*

Mountain bluebird

44

It's solitude

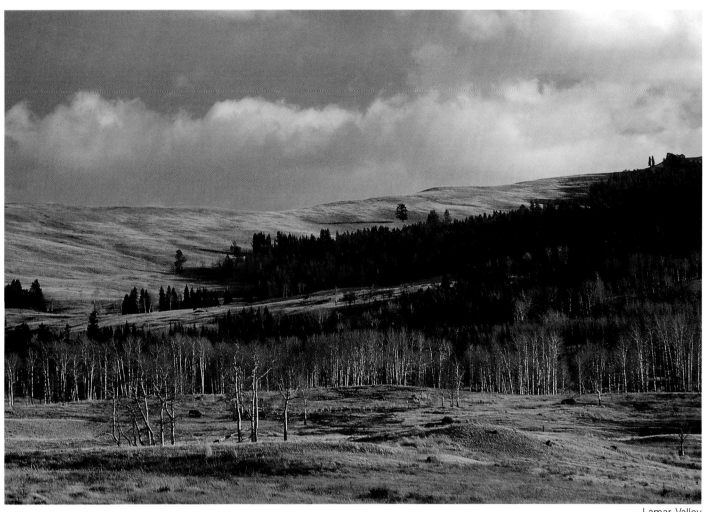

Lamar Valley

Trees turned to stone

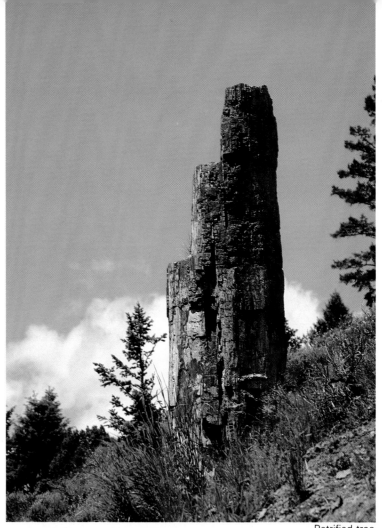

Petrified tree

And layers on an ancient cone.

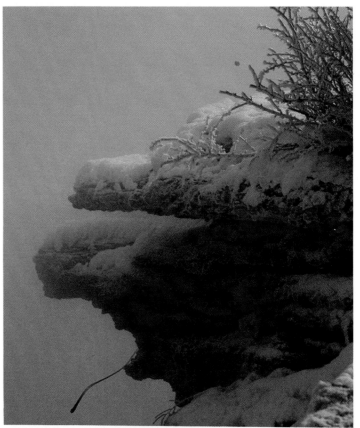

Soda Butte

46

It's saucy jays
John Colter's Hell
A rock shaped like the Liberty Bell.
It's referees
A visitor rare
And battle songs that fill the air.

It's saucy jays

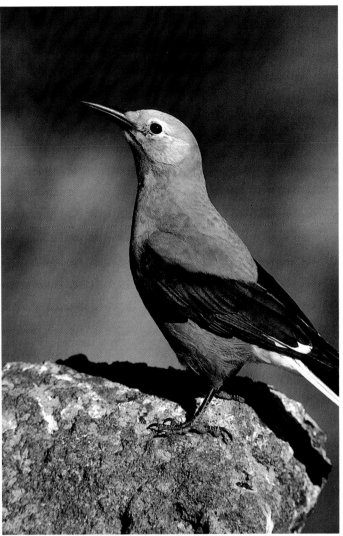

Clark's nutcracker

John Colter's Hell

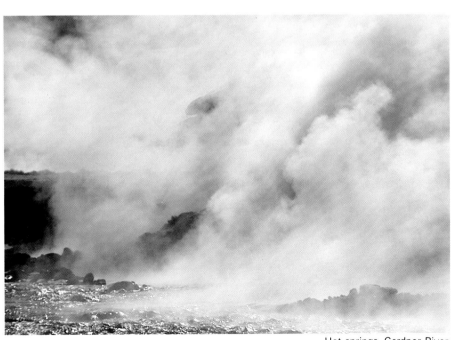

Hot springs, Gardner River

47

A rock shaped like the Liberty Bell.

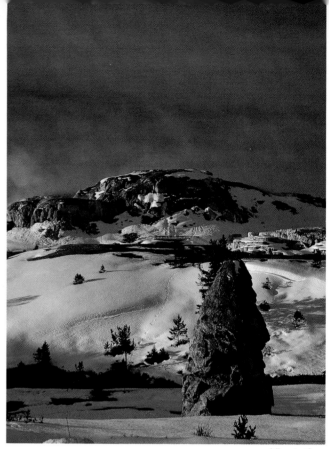

Liberty Cap

It's referees

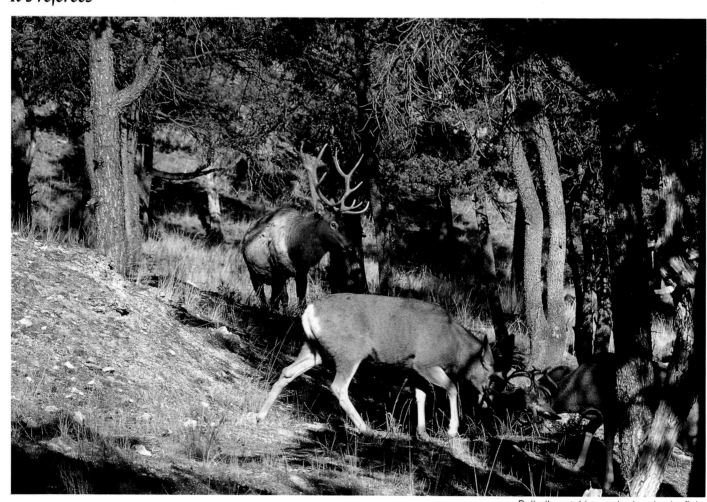

Bull elk watching mule deer bucks fight

A *visitor rare*

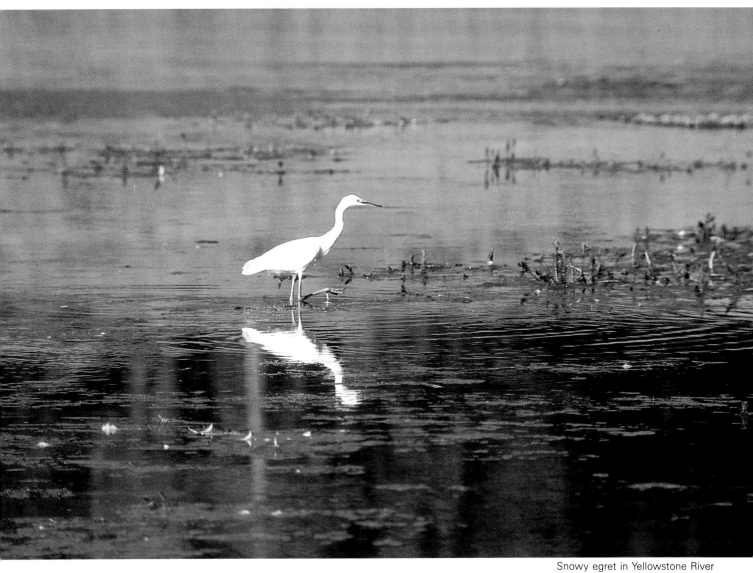

Snowy egret in Yellowstone River

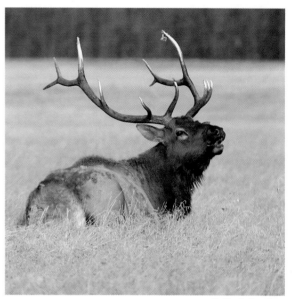

Bull elk bugling

And *battle songs that fill the air.*

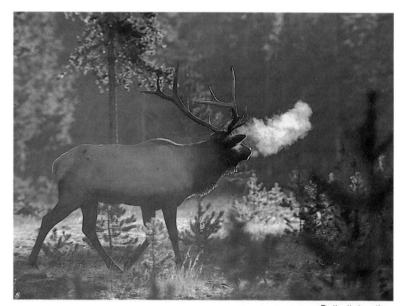

Bull elk bugling

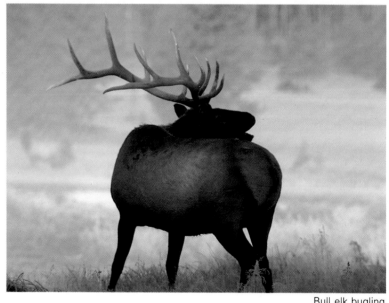

Bull elk bugling

It's golden dawns
And paintbrush bright
A bull moose spoilin' for a fight.
It's chipmunks quick
And silvered trees
Fog risin' when the rivers freeze.

It's golden dawns

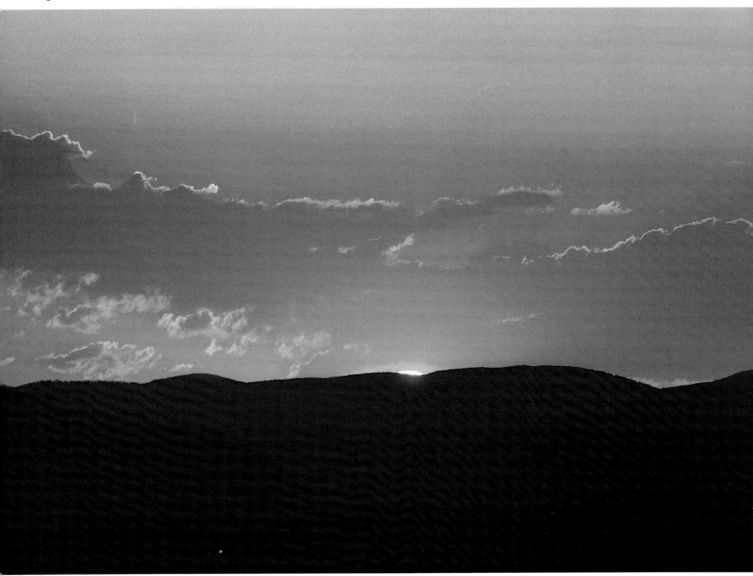

Dawn Hayden Valley

And paintbrush bright

Indian paintbrush

A *bull moose spoilin' for a fight.*

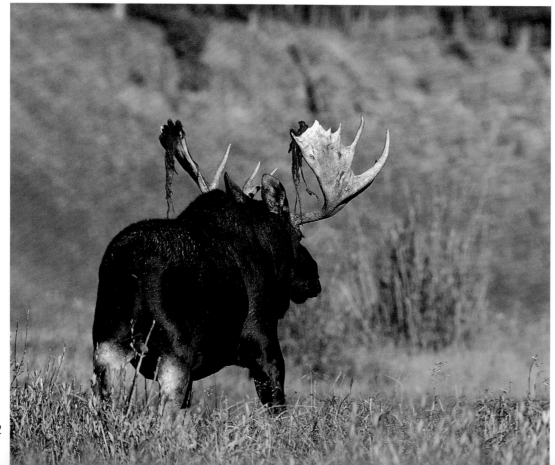

52

Bull moose

It's chipmunks quick

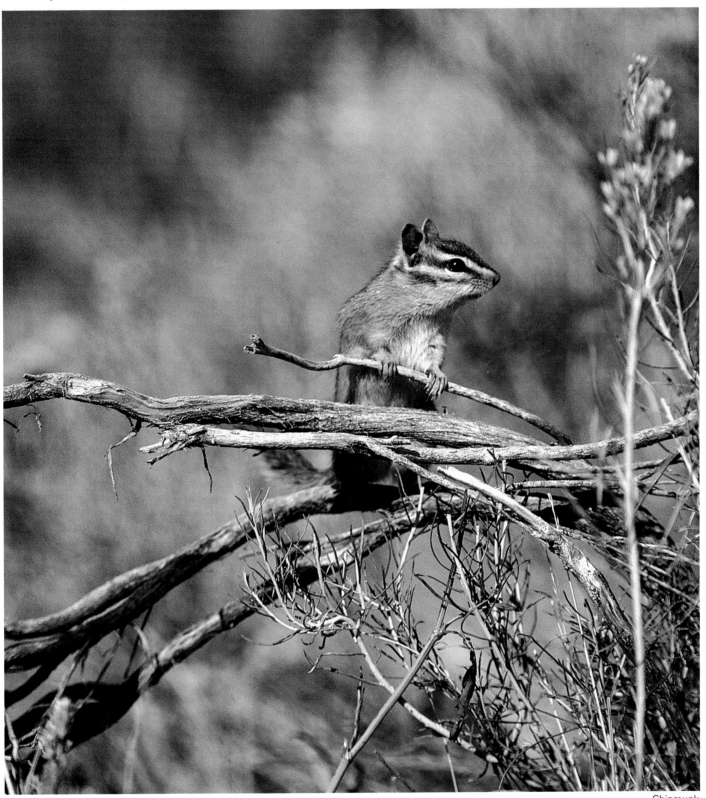

Chipmunk

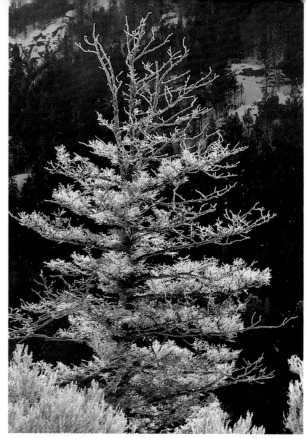

And silvered trees

Frosty tree

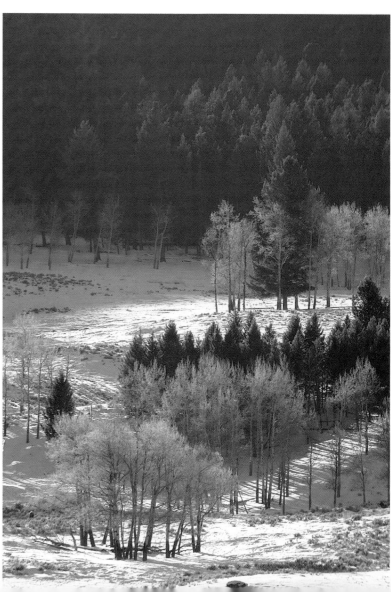

Lamar Valley

Fog risin' when the rivers freeze.

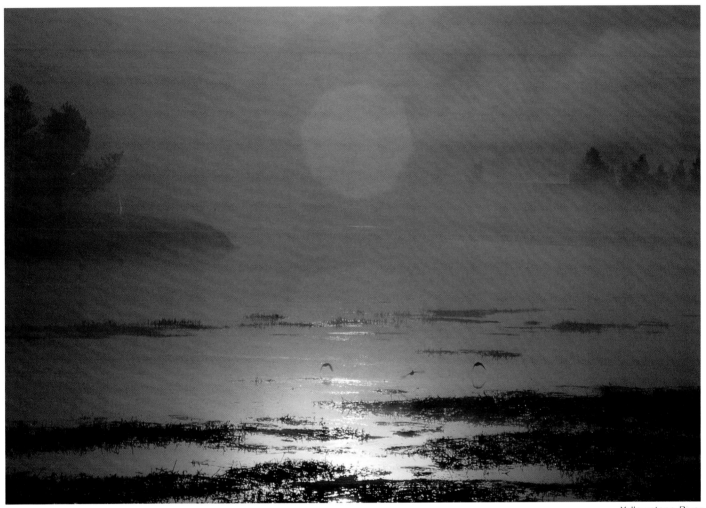

Yellowstone River

It's yellow-heads
And new green reeds
A riffle where the brown trout feeds.
It's bison calves
The winter god
And mountain monarchs on the prod.

It's yellow-heads

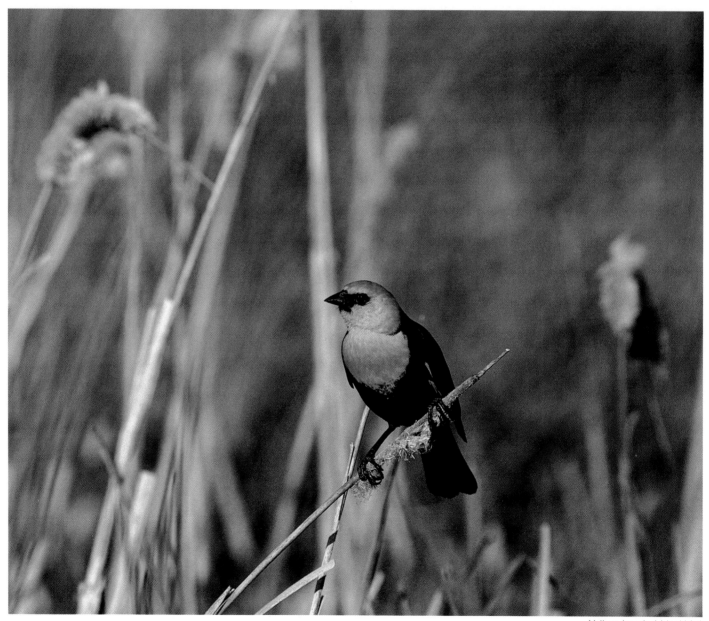

Yellow-headed blackbird

And new green reeds

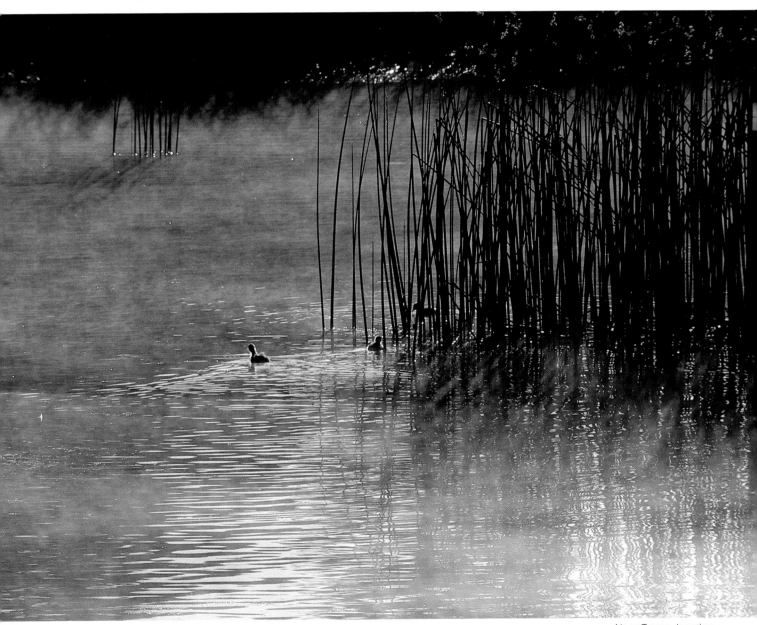

Near Tower Junction

A *riffle where the brown trout feeds.*

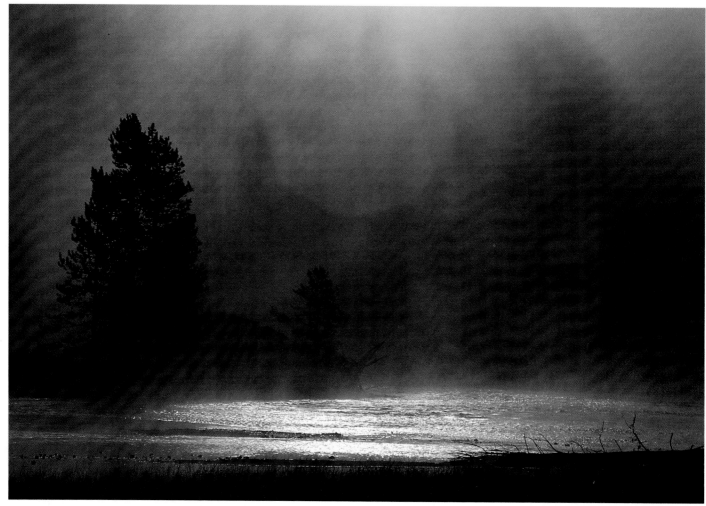

Madison River

It's *bison calves*

Bison calf with cows

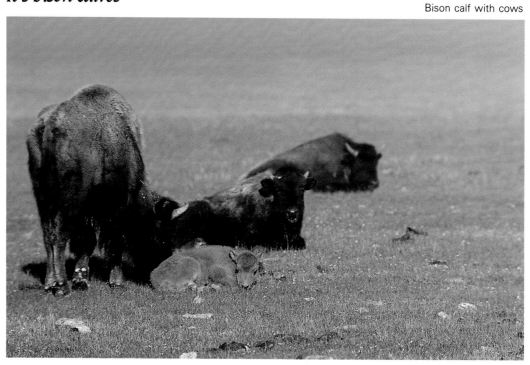

The winter god

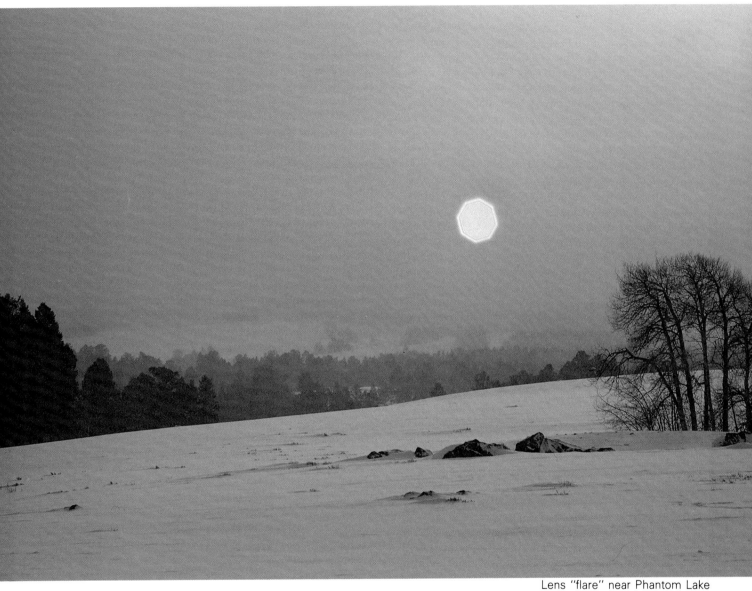

Lens "flare" near Phantom Lake

And mountain monarchs on the prod.

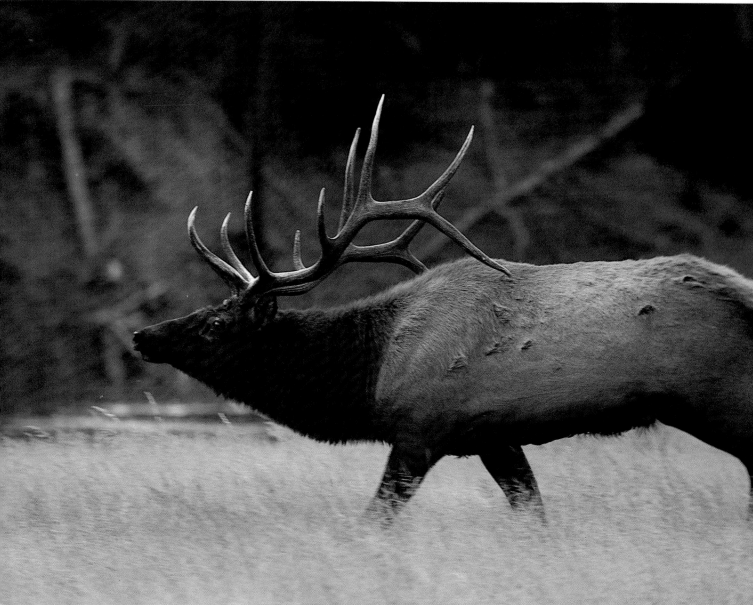

Bull elk

It's fireweed
Sun-gilded shrouds
And snow trails leadin' to the clouds.
It's waters warm
A jack turned white
And full moons when day turns to night.

It's fireweed

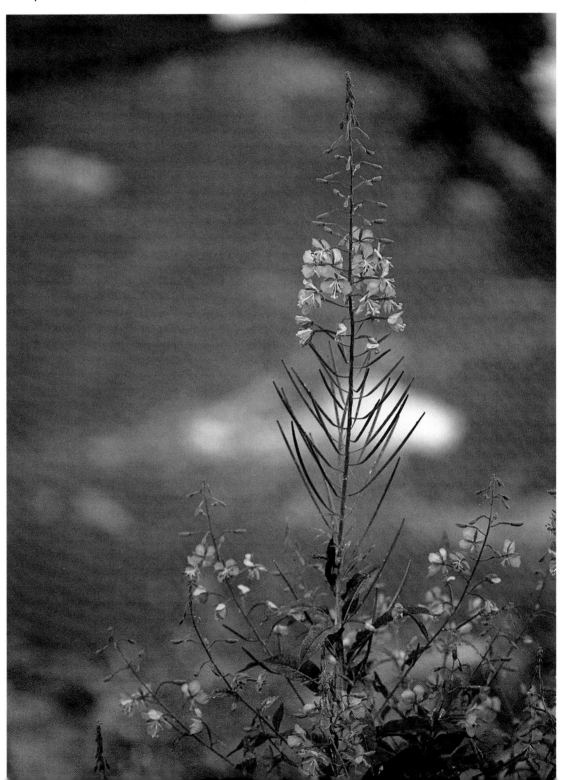

Fireweed

Sun-gilded shrouds

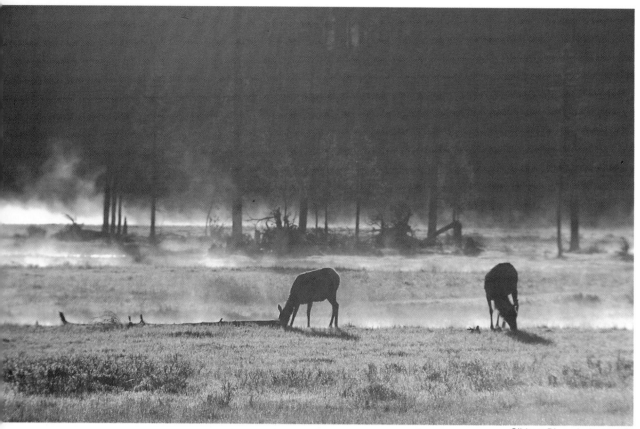

Gibbon River and cow elk

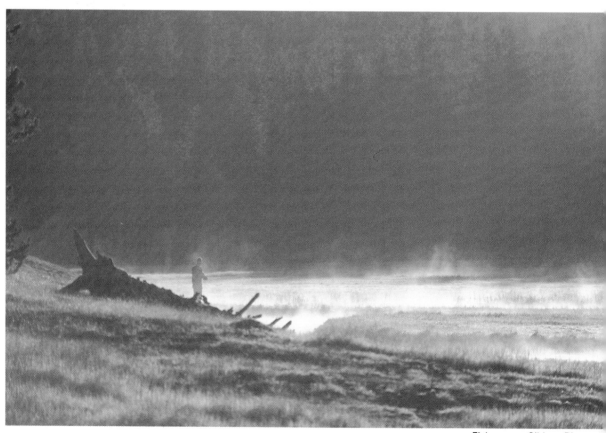

Fisherman, Gibbon River

And snow trails leadin' to the clouds.

Near Phantom Lake

It's waters warm

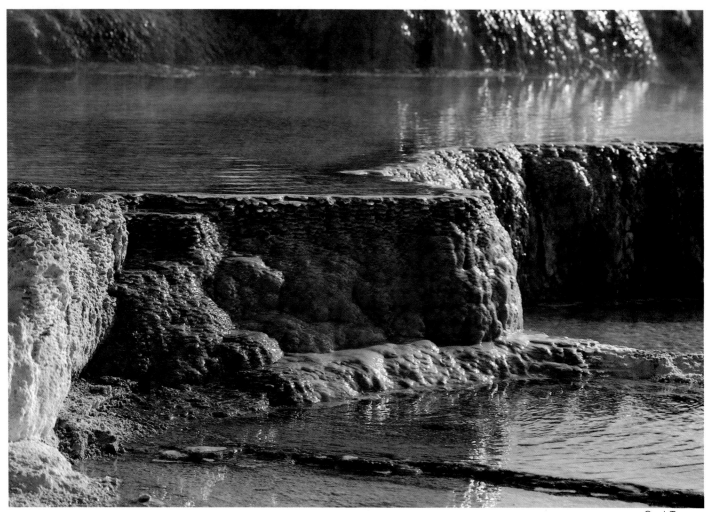

Opal Terrace

A jack turned white

Jackrabbit

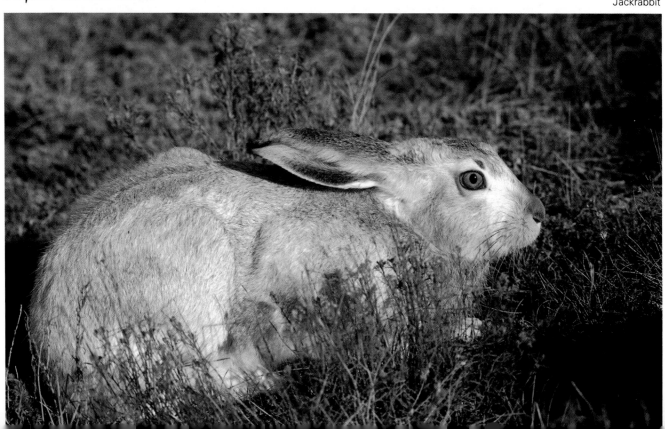

And full moons when day turns to night.

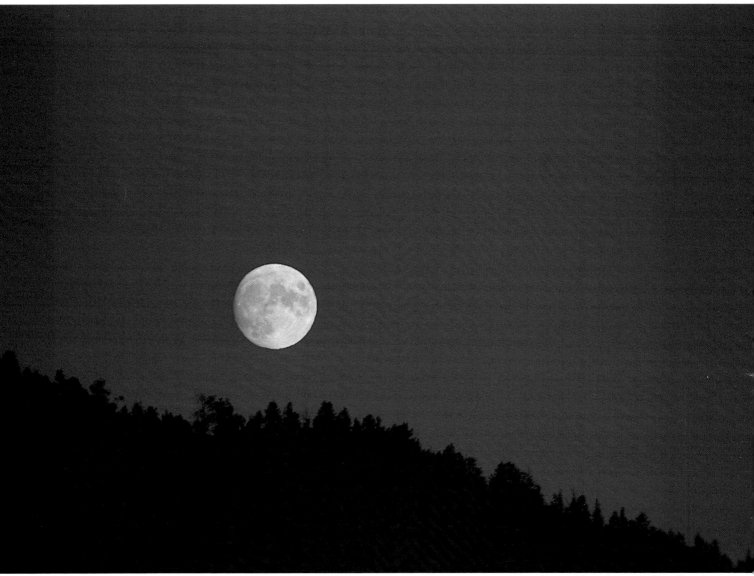

Moonrise near West Thumb

It's muley fawns
A gray-brown hen
A marmot watchin' near his den.
It's velvet crowns
A dipper's log
And far off bugles in the fog.

It's muley fawns

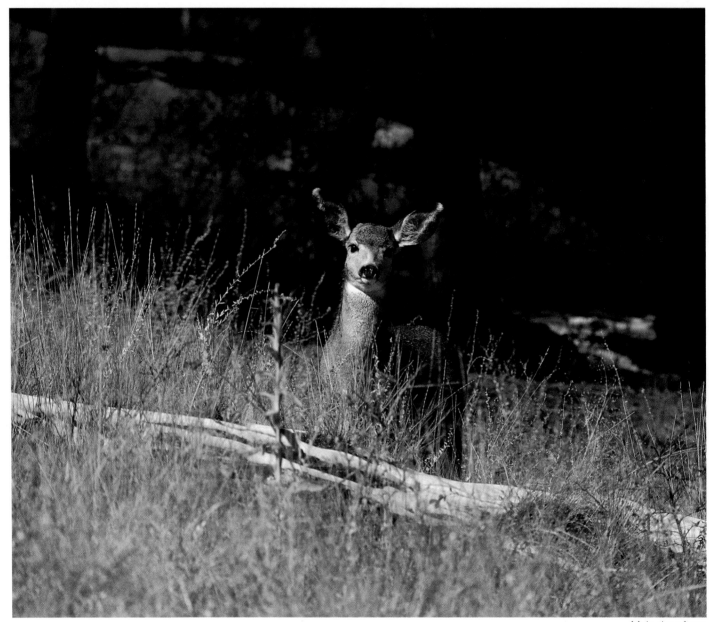

Mule deer fawn

A *gray-brown hen*

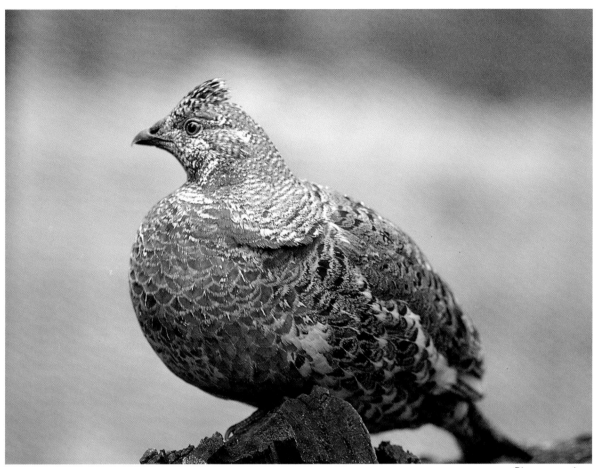

Blue grouse hen

A *marmot watchin' near his den.*

Yellow-bellied marmot

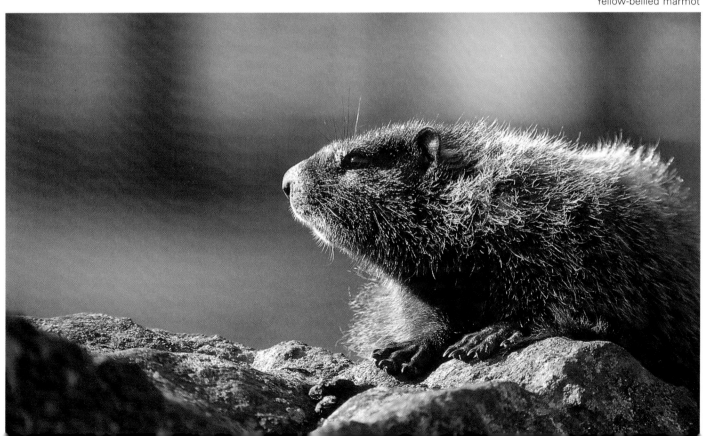

It's velvet crowns

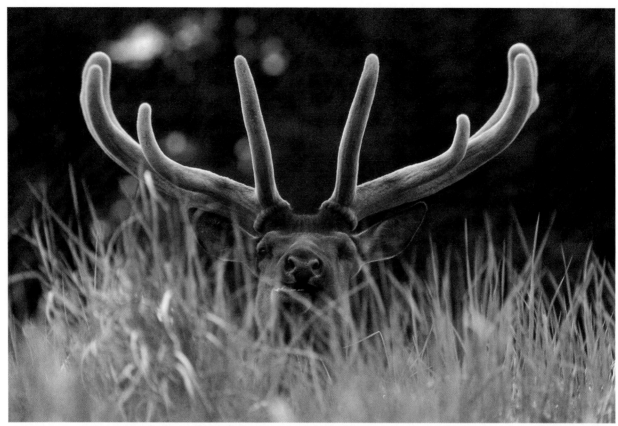

Bull elk in velvet

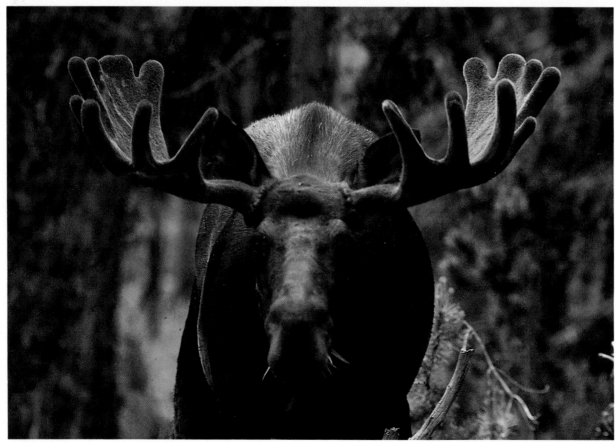

Bull moose in velvet

A *dipper's log*

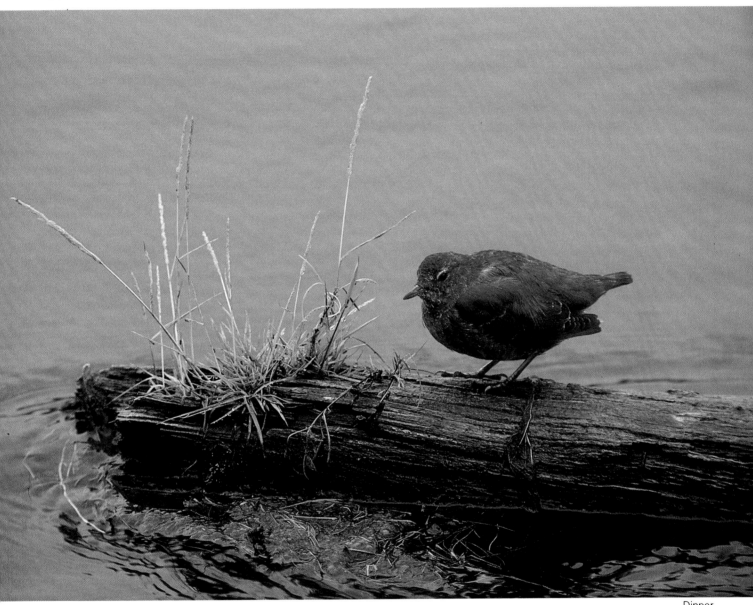

Dipper

And far off bugles in the fog.

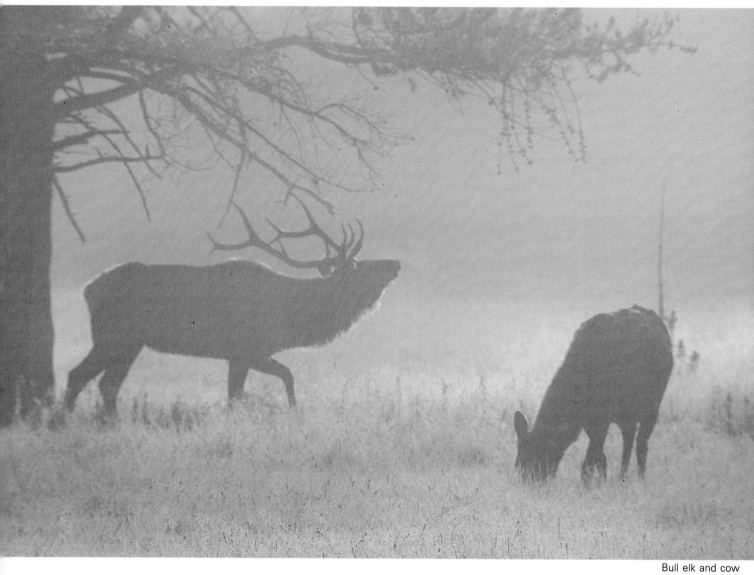

Bull elk and cow

It's bright-eyed lambs
And steam-shaped forms
And bull elk waitin' out the storms.
It's bridal veils
A pika's hay
And magpies up to greet the day.

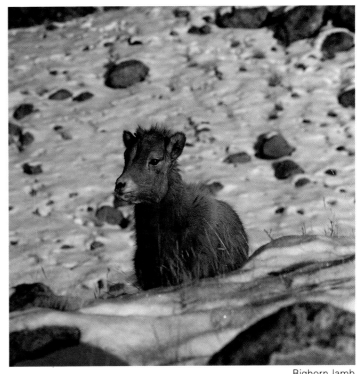

Bighorn lamb

It's bright-eyed lambs

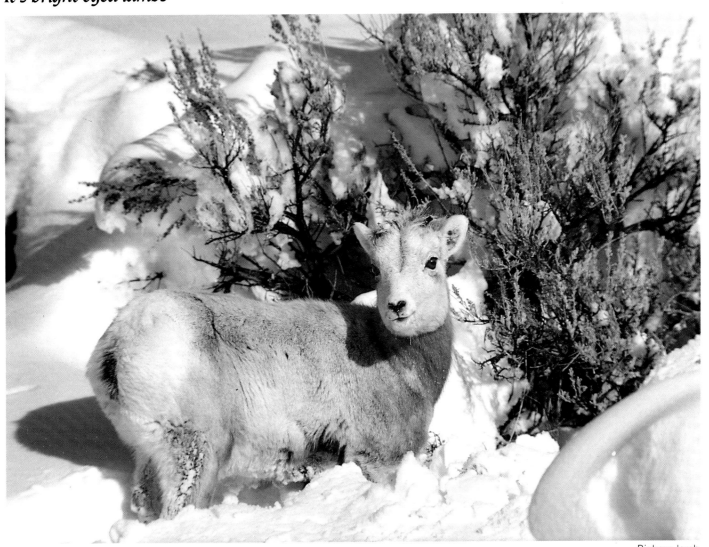

Bighorn lamb

71

And steam-shaped forms

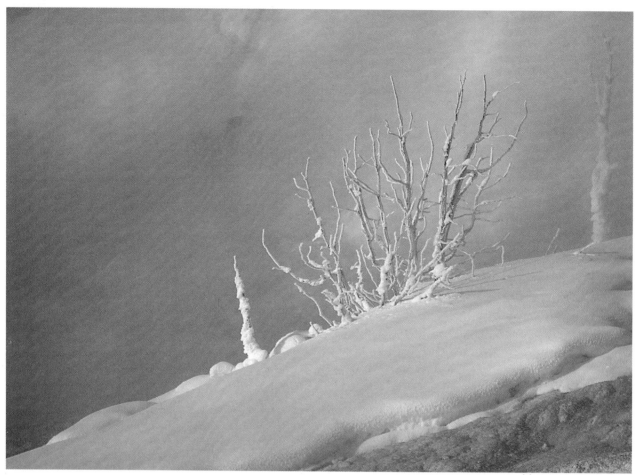

Mammoth Hot Springs

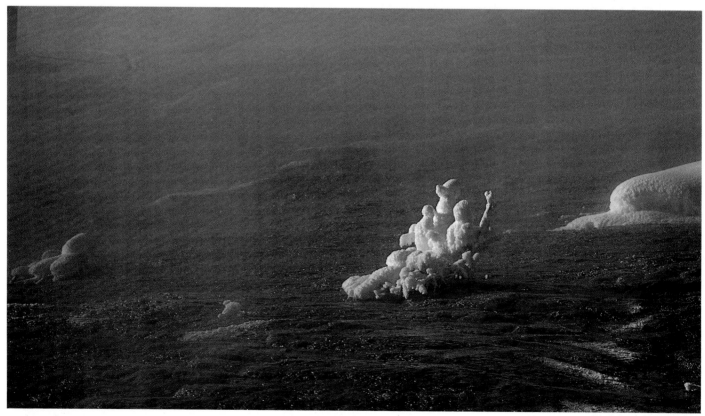

Mammoth Hot Springs

And bull elk waitin' out the storms.

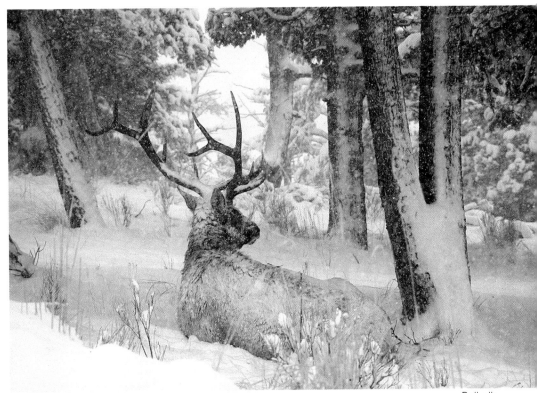

Bull elk

It's bridal veils

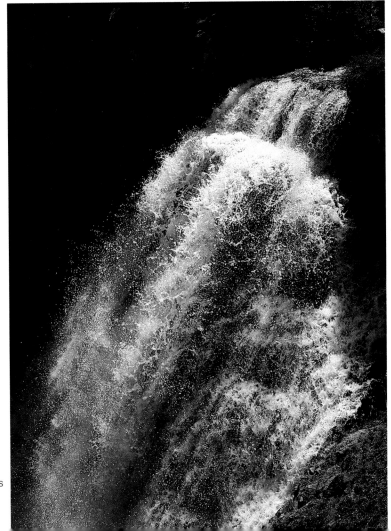

Bridal Veil Falls

A *pika's hay*

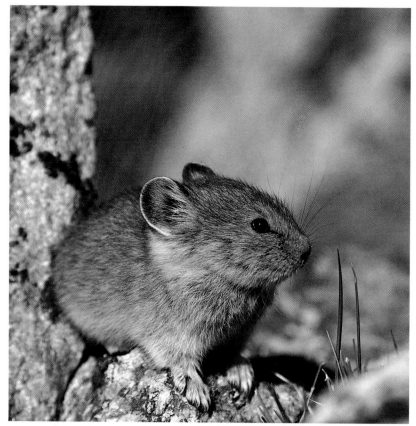

Pika

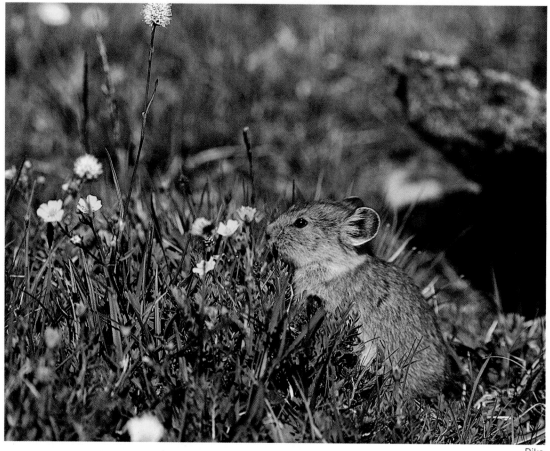

Pika

74

And magpies up to greet the day.

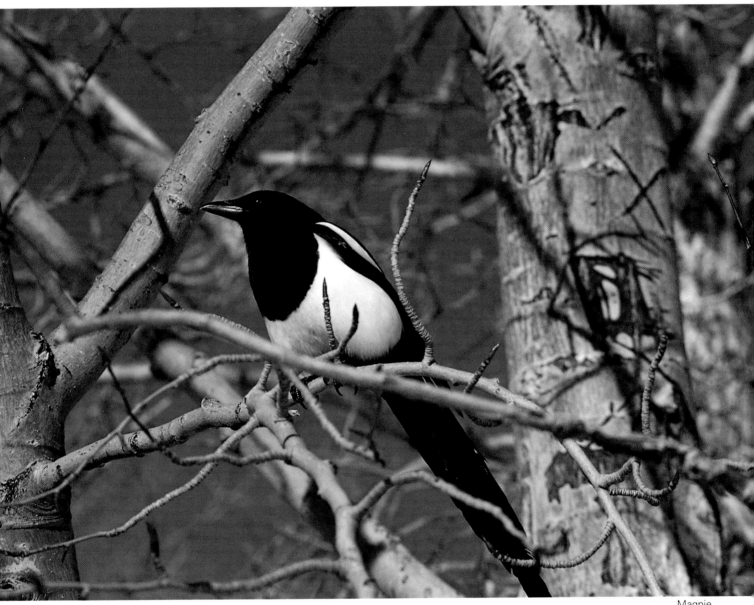

Magpie

It's tiny friends
A day new dawned
And aspens mirrored in a pond.
It's bottoms up
And bedded bucks
And snowblowers set on high-wheeled trucks.

It's tiny friends

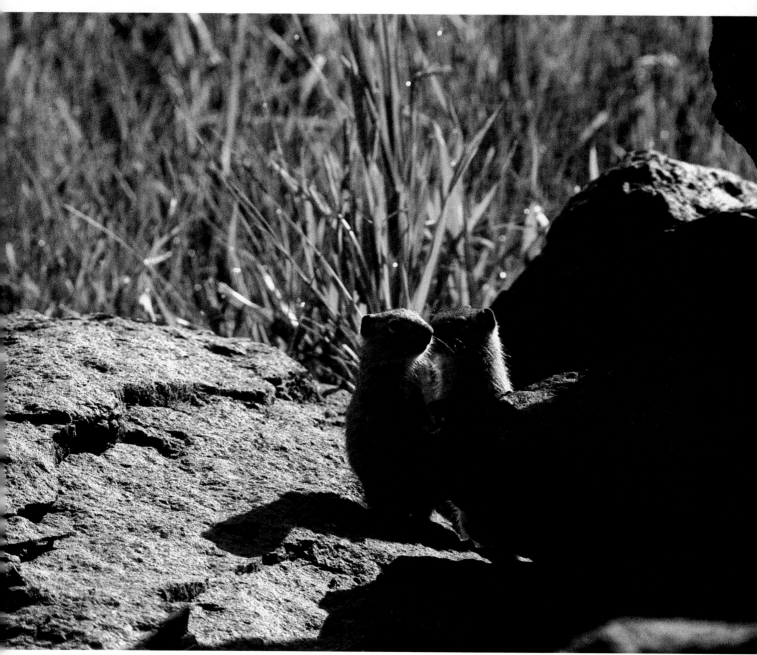

Baby ground squirrels

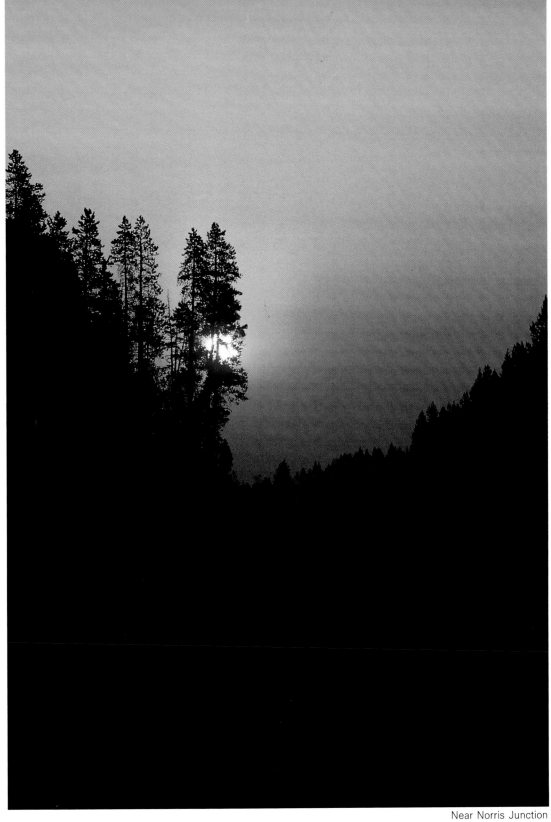

Near Norris Junction

A *day new dawned*

And aspens mirrored in a pond.

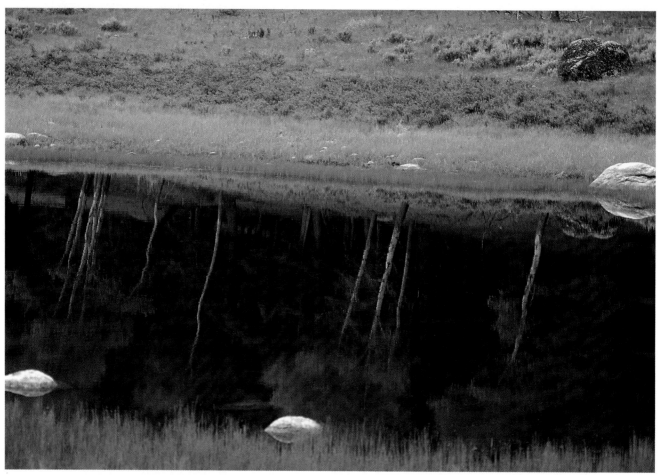

Near Tower Junction

It's bottoms up

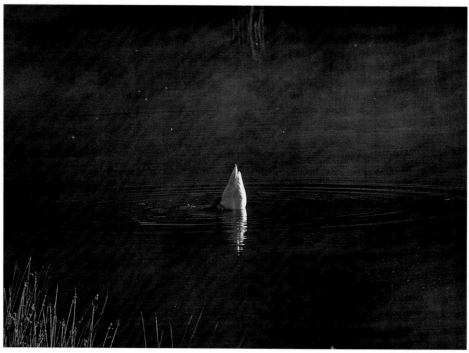

Trumpeter swan

And bedded bucks

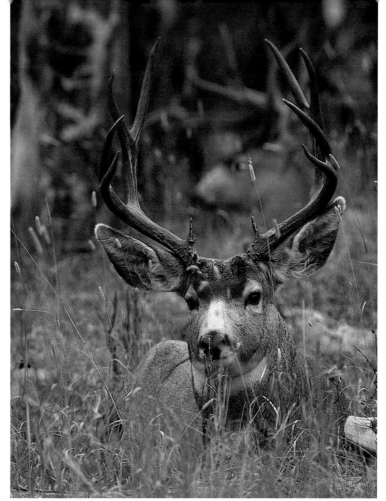

Mule deer bucks

And snowblowers set on high-wheeled trucks.

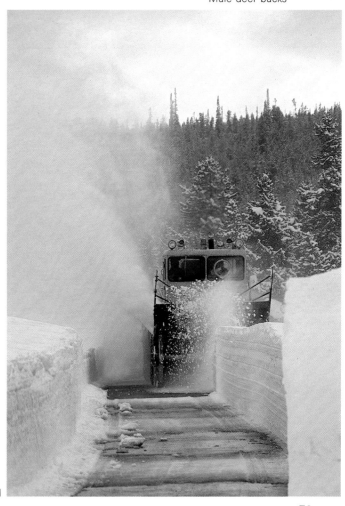

Snowblower near Old Faithful

It's prairie babes
And hawks that soar
A raven croakin' "Nevermore."
It's Tower Falls
And golden gates
And blue grouse dancin' for their mates.

It's prairie babes

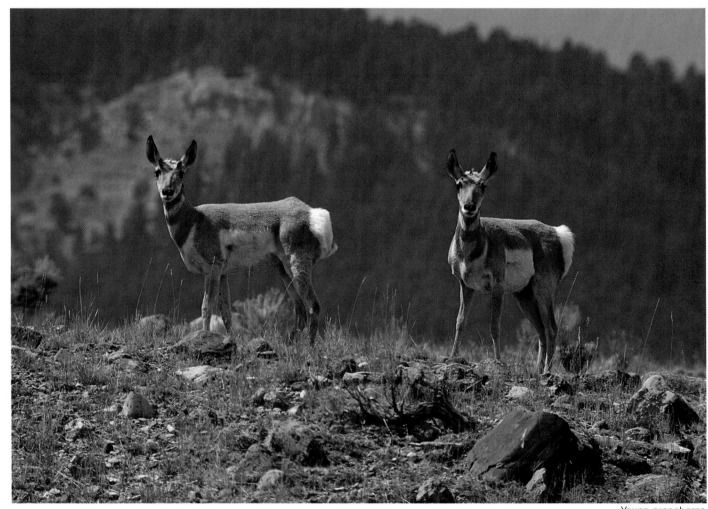

Young pronghorns

And hawks that soar

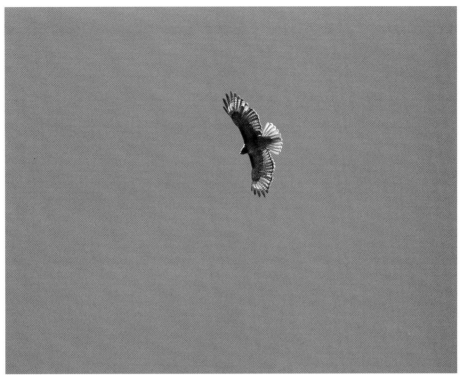

Hawk near Slough Creek

A raven croakin' "Nevermore."

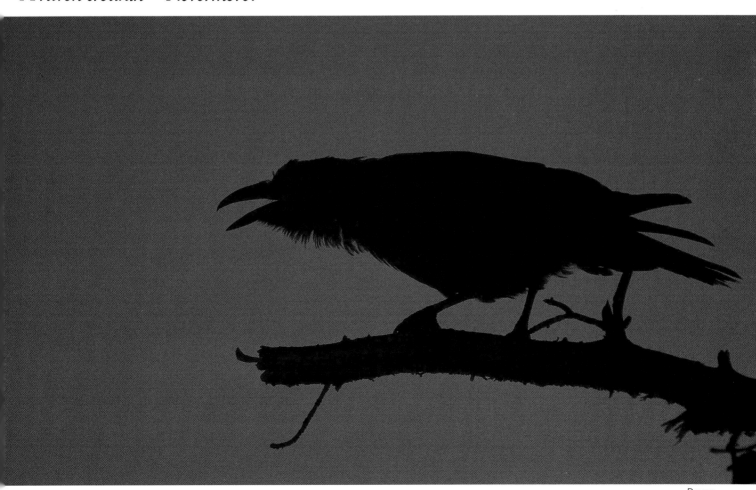

Raven

It's Tower Falls

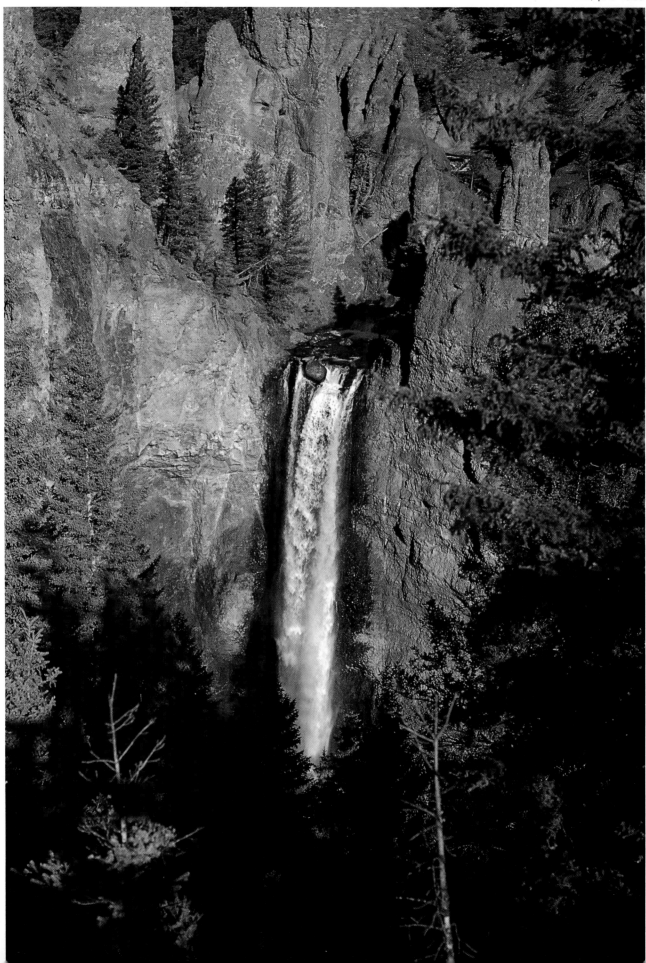

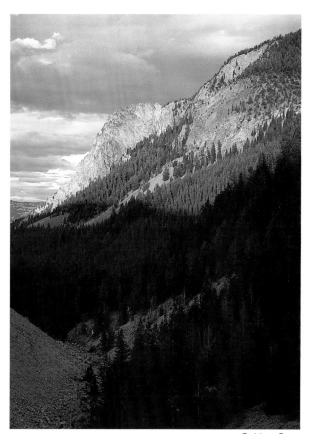

And golden gates

Golden Gate

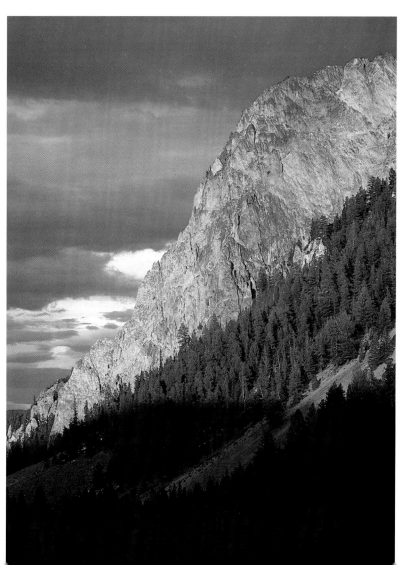

Golden Gate

And blue grouse dancin' for their mates.

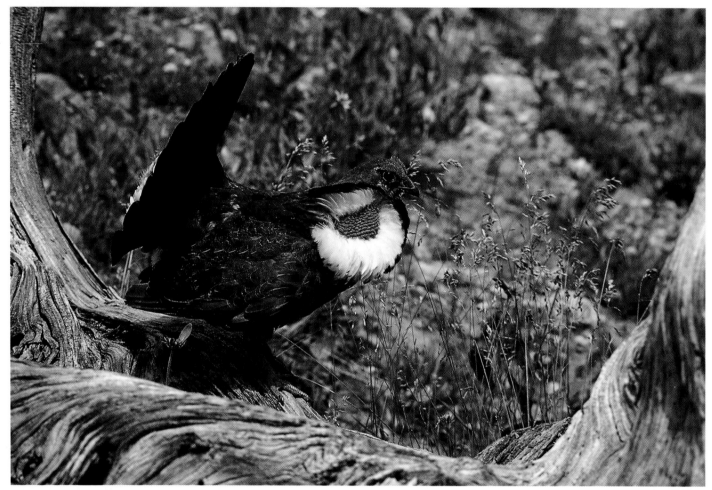

Blue grouse

It's ermine white
A hatch of flies
And mountains where great rivers rise.
It's fabled streams
A high skied tune
And ghosts that stalk the hunger moon.

It's ermine white

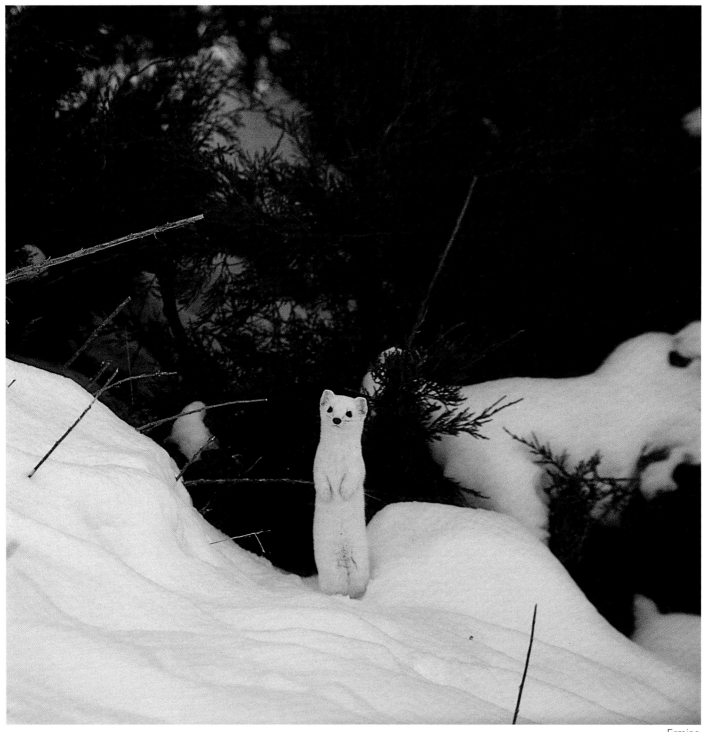

Ermine

A *hatch of flies*

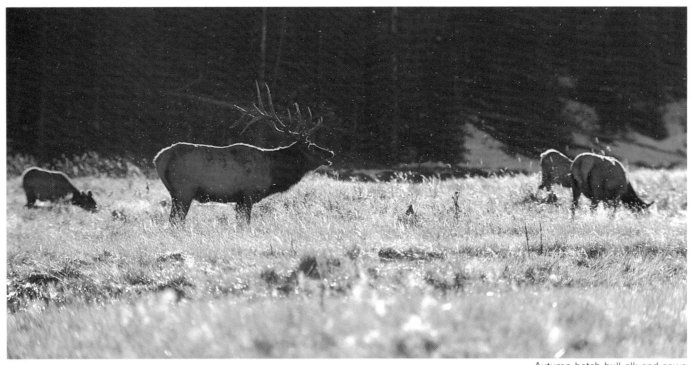

Autumn hatch bull elk and cows

And *mountains where great rivers rise.*

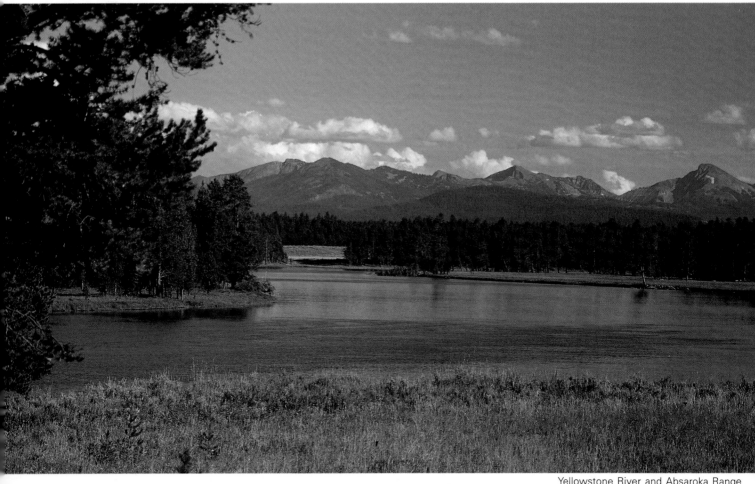

Yellowstone River and Absaroka Range

It's fabled streams

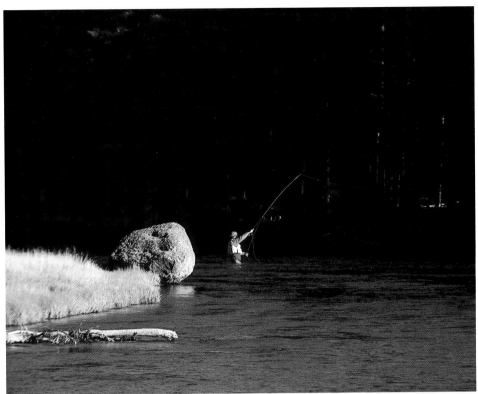

Madison River

Madison River flyfisherman

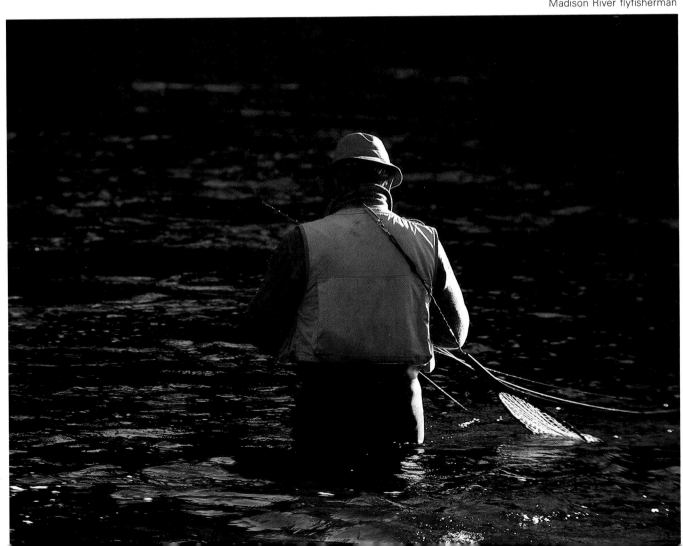

A *high skied tune*

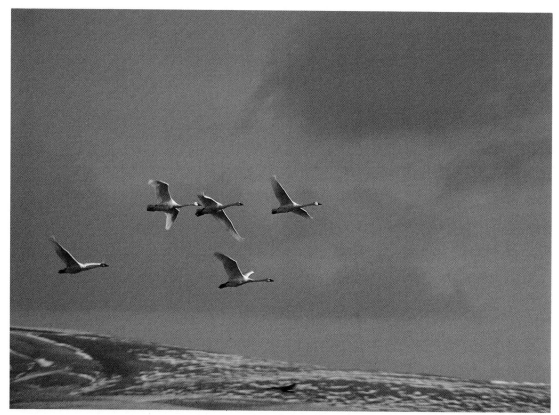

Whistling swans

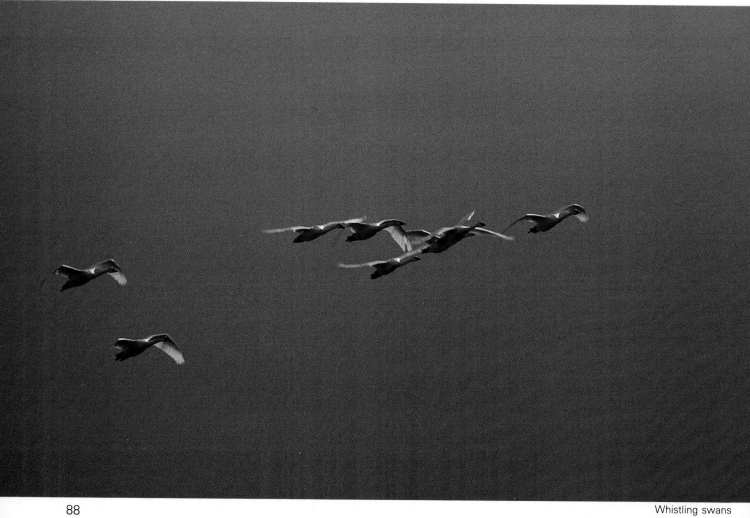

Whistling swans

And *ghosts that stalk the hunger moon.*

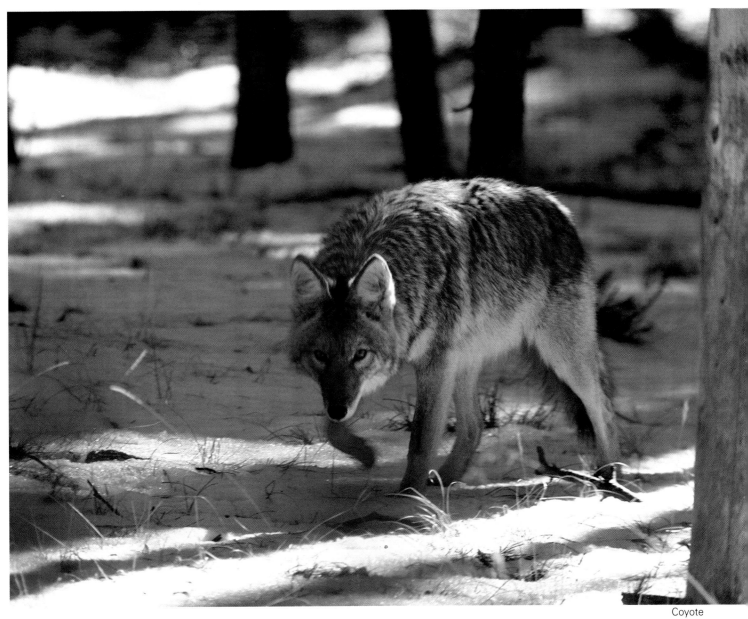

Coyote

It's fall black bears
A soft sunrise
And baby ospreys' great keen eyes.
It's bison cold
And lodgepole pines
And winter elk in long cold lines.
 Yellowstone Is . . .

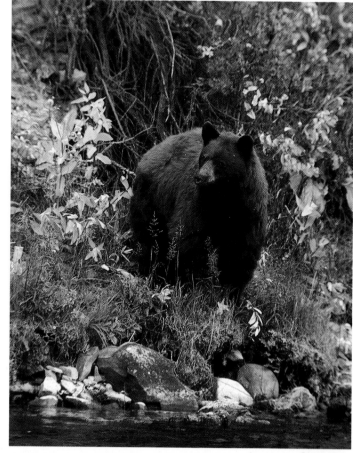

Black bear

It's fall black bears

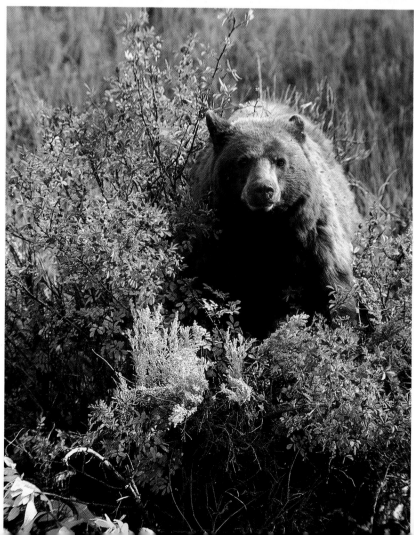

Black bear

90

A soft sunrise

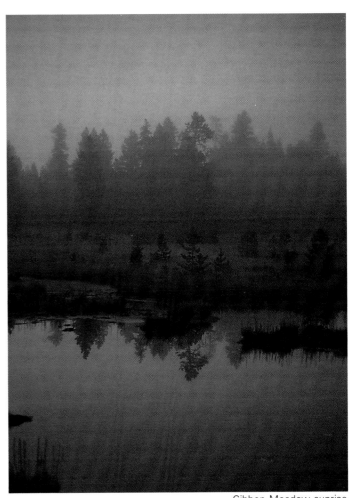

Gibbon Meadow sunrise

And baby ospreys' great keen eyes.

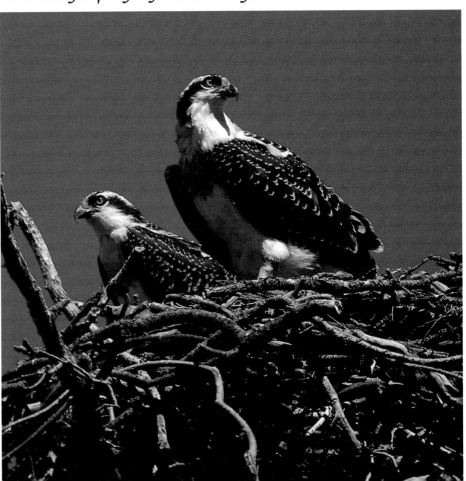

Baby ospreys

It's bison cold

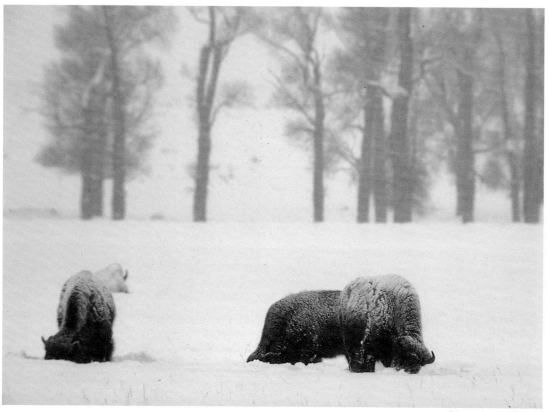

Bison, Lamar Valley

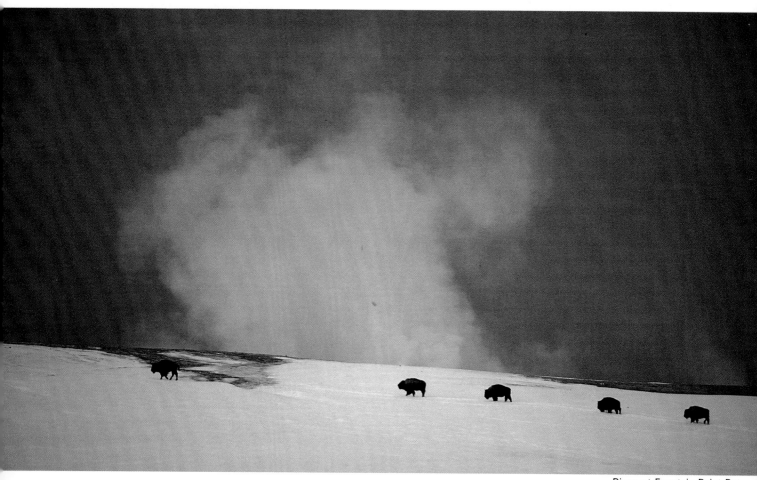

Bison at Fountain Paint Pot

And lodgepole pines

Lodgepole pines

And winter elk in long cold lines.

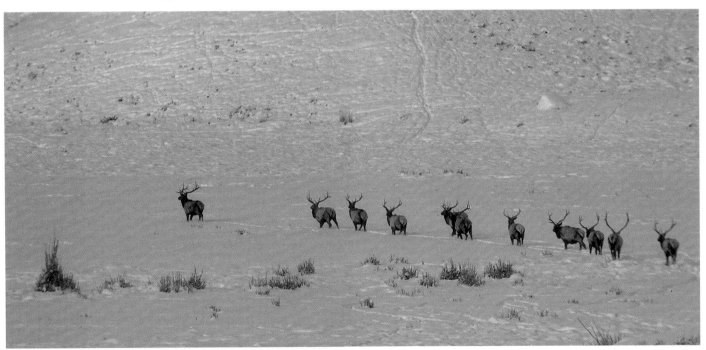

Bull elk, Tower Junction

Yellowstone Is . . .

Mike Logan. Sean Logan photo

Montana Is . . .

Mike Logan shares his love for the Treasure State in this beautiful companion to *Yellowstone Is . . .* An exuberant blending of verse and full-color photography.
96 pp., 8 ½" X 11", 140 color photos, **$13.95** softcover

Montana Is . . . Video

A video roundup of Mike Logan's visual impressions of Big Sky Country, its ranch life, scenic beauty, and spectacular wildlife. Join Mike as he reads from *Montana Is . . .*, and from his three collections of cowboy poems.
34 minutes, VHS, **$15.95**

Bronc to Breakfast & Other Poems

This poignant and powerful collection of cowboy poetry captures the essence of western life.
80 pp., 5 ½" X 8 ½", illus., **$9.95** softcover
Leather-bound edition, signed and numbered (not pictured), **$50.00**
Bronc to Breakfast Audio Tape (not pictured), **$9.95**

Laugh Kills Lonesome & Other Poems

More cowboy poetry from the master storyteller.
80 pp., 5 ½" X 8 ½", illus., **$9.95** softcover
Laugh Kills Lonesome Audio Tape (not pictured), **$9.95**

Men of the Open Range & Other Poems

(not pictured)
Mike Logan's latest collection of cowboy poems.
80 pp., 5 ½" X 8 ½", illus., **$9.95** softcover
Men of the Open Range Audio Tape (not pictured), **$9.95**

Little Friends (not pictured)

In down-to-earth verse and crisp photography, *Little Friends* celebrates the small, furry mammals of the American West—from the tiny pika to the curious ermine. For young readers.
32 pp., 9 ¼" X 8 ¼", 40 color photos, **$9.95** softcover

About the Author

Veteran photographer Mike Logan's lifelong interest in ranch life has spurred him to capture his observations on film and in verse. Mike's keen insight and expansive western spirit have won him national acclaim, both as a featured poet and emcee at The National Cowboy Poetry Gathering in Elko, Nevada, and as a guest on John Denver's 1991 "Montana Christmas Skies" television special. His words and photographs have also been published in numerous books, magazines, and calendars.

Mike's fascination with Yellowstone began nearly thirty years ago. Just out of high school, on a trip from his native southeast Kansas to work for the U.S. Forest Service in Idaho, he passed through Yellowstone. He never fully recovered from the experience.

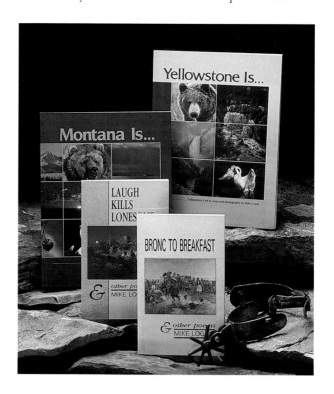

Send orders for *Yellowstone Is. . .* and Mike Logan's other books and tapes to:

Buglin' Bull Press
32 S. Howie
Helena, MT 59601

Add $1.50 per book for postage and handling.